IMAGES
of America

LIGHTHOUSES OF TEXAS

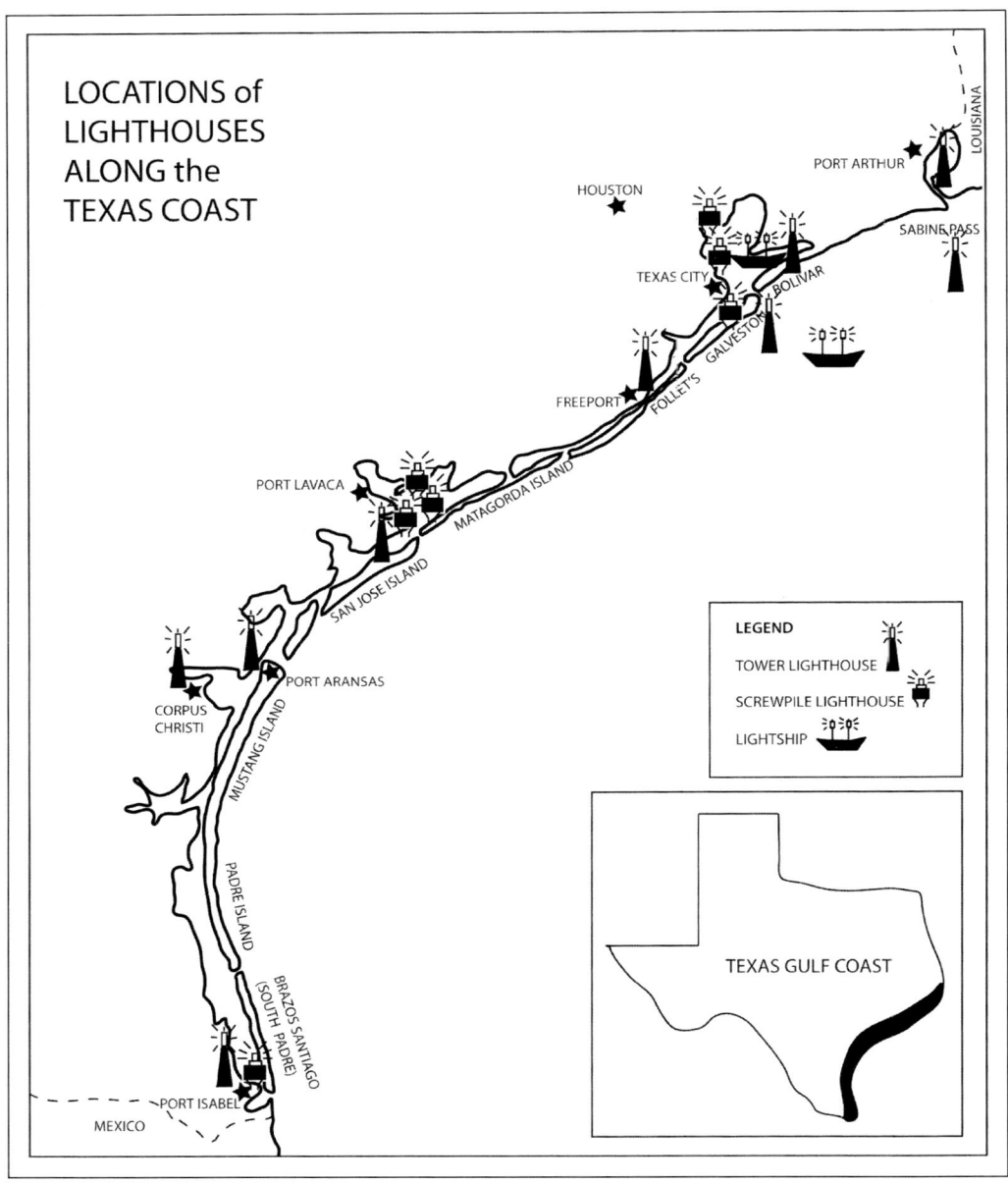

This map of the Texas Gulf Coast shows the location of all lighthouses—past and present, extant and lost—that, since the 1850s, have served those sailing the waters of the Lone Star State. (Map created by the author.)

ON THE COVER: This 1984 aerial view shows the Bolivar Point lighthouse and keeper's quarters. This is the second lighthouse built at this location; the original tower was dismantled during the Civil War, and this replacement was built in 1871. It was deactivated in 1933 and has been privately owned since the 1940s. (Courtesy of the US Coast Guard Historian's Office.)

IMAGES
of America

LIGHTHOUSES OF TEXAS

Steph McDougal

ARCADIA
PUBLISHING

Copyright © 2014 by Steph McDougal
ISBN 978-1-4671-3091-2

Published by Arcadia Publishing
Charleston, South Carolina

Printed in the United States of America

Library of Congress Control Number: 2013945663

For all general information, please contact Arcadia Publishing:
Telephone 843-853-2070
Fax 843-853-0044
E-mail sales@arcadiapublishing.com
For customer service and orders:
Toll-Free 1-888-313-2665

Visit us on the Internet at www.arcadiapublishing.com

*For Alan: my best friend, the love of my life,
and the perfect partner for every adventure.*

Contents

Acknowledgments 6
Introduction 7
1. Lightships, Towers, and Bugs 9
2. The Life-Saving Service 37
3. Screwpiles, a Lightship, and a Caisson 49
4. Wars, Hurricanes, and Destruction 71
5. Automation, Abandonment, and Rebirth 93
Bibliography 127

Acknowledgments

This book would not have been possible without the generous assistance of archivists and librarians. Many thanks to Dr. Robert Browning, US Coast Guard (USCG) historian, and Christopher Havern, senior staff historian at USCG in Washington, DC; Jamie Murray, Brazoria County Historical Museum, Angleton; Sheron Barnes, University of Victoria-Houston, Victoria; Gerlinda Riojas, Corpus Christi Public Library; Pamalla Anderson, DeGolyer Library at Southern Methodist University, Dallas; Beth Steiner, Moore Memorial Library in Texas City; Carolyn Cauley, Aransas County Historical Commission, Rockport; George Anne Cormier, Calhoun County Museum, Port Lavaca; Jami Durham, Galveston Historical Foundation Preservation Resource Center; Lee Pecht, Woodson Research Center, Rice University; Valerie Bates, Museums of Port Isabel; Richard Whitaker, Port Arthur Public Library; and Adam Watson, State Archives of Florida.

Thanks to the many historians and enthusiasts who have written about and photographed lighthouses, especially the late David Cipra, author of *Lighthouses, Lightships, and the Gulf of Mexico*, whose compiled research notes in the USCG historian's office were an invaluable timesaver.

As a graduate student at Miami University in Oxford, Ohio, I learned to write at a professional level and to apply a problem-solving approach to just about everything. The Master of Technical and Scientific Communication program has been discontinued, but I owe a debt of gratitude to the faculty: Paul Anderson, Jennie Dautermann, Robert Johnson, and Jean Lutz, and to my assistantship supervisor, Susan Gertz (MTSC '95).

My friend and colleague Anna Mod (author of Arcadia Publishing's *Building Modern Houston*) led the way, as usual, and shared valuable advice about marketing and publicity. My editors at Arcadia, Lauren Hummer and Laura Bruns, are enthusiastic and a pleasure to work with.

Finally, thanks to my friends and family for their support, especially Jamie Fisher, who provided a base of operations in Washington, DC; Diane McDougal, who is always up for a road trip; and my husband, Alan.

Unless otherwise noted, all images appear courtesy of the US Coast Guard Historian's Office. This book was written with Scrivener on a Mac.

Introduction

It may surprise some readers to learn that the Texas coastline is comprised of a string of barrier islands, not unlike the Outer Banks in North Carolina. In fact, much of the entire lengths of the Gulf and Atlantic Coasts of the United States are lined with barrier islands. These narrow strips of land—made up of beaches, sand dunes, mud flats, and salt marshes—shelter bays and lagoons from waves and weather. Texas contains seven barrier islands; from northeast to southwest, they are Galveston, Follet's, Matagorda, St. Joseph (also known as San Jose), Mustang, Padre, and Brazos Santiago. Padre Island, at 113 miles long, is the longest barrier island in the world and the longest stretch of undeveloped beach in America.

A seaside resort may not exactly be what springs to mind when one pictures the "Texas" depicted in motion pictures and television shows, but beaches, hunting and fishing, bird-watching, and recreational boating make up a large part of Lone Star State culture. The Texas coast is nearly 400 miles long, and the fourth largest fleet of recreational sailboats in the nation is docked in Clear Lake, an inlet just off Galveston Bay.

Texas's beaches are probably so popular because the Gulf of Mexico is shaped like a shallow bowl with a wide, nearly-flat rim. Although the Gulf is nearly 12,000 feet deep at its deepest point, the waters along the Texas coast are quite shallow, and the tides only rise and fall about two feet. That long, gradual approach to land creates a playground for sun lovers and families—even surfers!—but can be treacherous for sailors. The Texas Gulf Coast has long been fraught with danger for those who dare to approach it by sea.

As early as 1554, a Spanish flotilla was lost off Padre Island. The shallow waters of the Gulf of Mexico claimed *La Belle*, the flagship of French explorer René Robert Cavelier, Sieur de la Salle, near Matagorda Bay in 1685. Shipwrecks and pirates—most notably, the notorious brigand Jean Lafitte—took an untold number of boats in the early 1800s. During the Civil War, both Union and Confederate ships were sunk, by both enemy forces and underwater hazards, while trying to reach strategically important ports along the Texas coast.

Before the Republic of Texas gained its independence from Mexico in 1836, and continuing until after the Civil War, this land was still very much a frontier. Few overland routes from the east were passable. The development of Texas was made possible because lighthouses enabled safe passage for immigrants and the shipping of goods to and from ports that connected early railroads to the state's interior. However, shipwrecks were still a regular and frequent occurrence for freighters and steamships serving Texas's growing economy in the 1800s and early 1900s.

Lighthouses marked the shoals, bars, jetties, and narrow passes through the barrier islands. Without these lighthouses, the settlement of Texas by immigrants from across Europe and Asia, as well as the American Upper South—and the amalgamation that gave rise to a rich mix of Texan music, food, culture, and traditions—would not have been possible.

The US Lighthouse Service is nearly as old as the United States itself. The first lighthouse in the American colonies was in Boston Harbor and was placed into service in 1716. Its construction

and operation were paid for through taxes charged to vessels entering or leaving the harbor. Locally funded and managed lighthouses were common in the colonies until after the United States declared its independence from England in 1776. The first US Congress established the Lighthouse Service in 1789. It was run (somewhat poorly and on the cheap) by bureaucrats and accountants until 1852, when the management of the reorganized US Lighthouse Board was placed into the hands of military officers and engineers. That same year saw the construction of Texas's first permanent lighthouses.

The first navigational aids along the Texas coast were often simple wooden towers erected on or near the beach. Over time, as funds became available and land could be secured, these temporary structures were replaced by towers made of brick or of prefabricated cast iron plates bolted together. As the years went on, many of Texas's lighthouses were moved or rebuilt in new locations—the result of coastal erosion and shifting sandbars or wartime destruction.

During the Civil War, Texas lighthouses were valuable observation posts for both Confederate and Union forces, and because—or in spite—of this, many were damaged or destroyed. Cast-iron towers were dismantled, possibly to be turned into cannonballs or other armaments; lenses and lanterns were stored or buried in the sand and mud to prevent their use by enemy forces; and explosives were detonated in or around lighthouse towers. After the war, it took years for all of the lighthouses to be repaired or rebuilt. The federal government took these opportunities to move lighthouses to more suitable locations, make them taller, and install better lamps and lenses.

The US Life-Saving Service was also active on the Texas coast, with life-saving stations near the major lighthouses. The first five stations were established in the late 1870s at Sabine Pass, Galveston, Saluria (Port O'Connor), Mustang Island (Aransas Bay), and Brazos Island (Brazos Santiago). An additional station was built at Velasco (Brazos River) in 1888. From 1848 to 1915, the Life-Saving Service maintained 269 such stations along the coastline of the United States. Each station was manned by experienced surfmen and a captain/keeper, all of whom were responsible for rescuing stranded crew and passengers using rowboats and a system of shore-to-ship equipment. In 1915, the Life-Saving Service merged with the US Revenue Cutter Service (which enforced maritime law) to form the US Coast Guard. Twenty-four years later, in 1939, the Coast Guard absorbed the Lighthouse Service.

As the 20th century progressed, the need for lighthouses diminished. The Intracoastal Waterway, a coastal shipping canal that covers 1,300 miles from Texas to Maine, was dredged between the barrier islands and the mainland from Corpus Christi, Texas, to the Louisiana border. Shipping lanes through the Gulf of Mexico became standardized. Relatively inexpensive range lights—pairs of lights positioned over water or land and used to determine position at sea—almost entirely replaced lighthouses as navigational aids.

The role of lighthouse keepers also changed dramatically in the second half of the 20th century as lamps were electrified and mechanisms automated, fog bells were replaced by electric horns, and radio beacons were installed to provide better positioning data to ships approaching from the sea. One by one, Texas's lighthouses were automated, abandoned, or sold as surplus. A few of the lighthouse's Fresnel lenses were removed and placed in local museums. Today, only a few Texas lighthouses remain, but their stories continue to capture our imaginations.

One

LIGHTSHIPS, TOWERS, AND BUGS

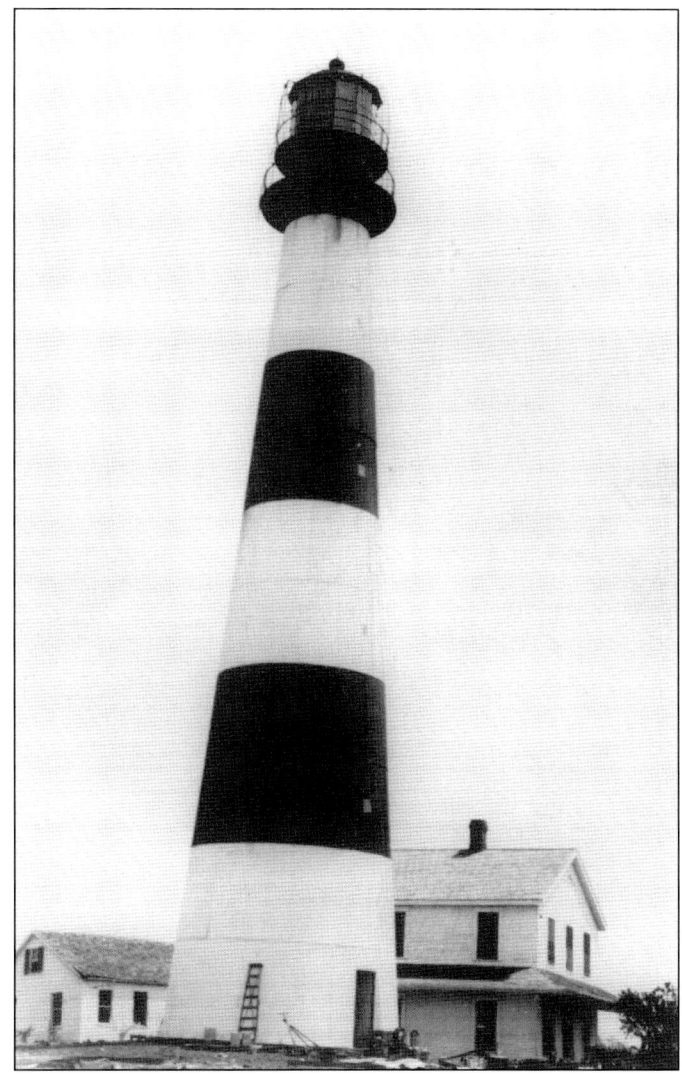

The Texas coast has been lined by lighthouses for more than 160 years. Lone Star lighthouses, operated by brave men and women through deadly storms and four wars, have brought tens of thousands of ships safely into port. After World War II, advances in automation technologies eliminated the need for manned stations, and eventually Texas's historic lighthouses were all extinguished, replaced by modern beacons. A few remain; this is their story. Pictured here is Bolivar Point lighthouse.

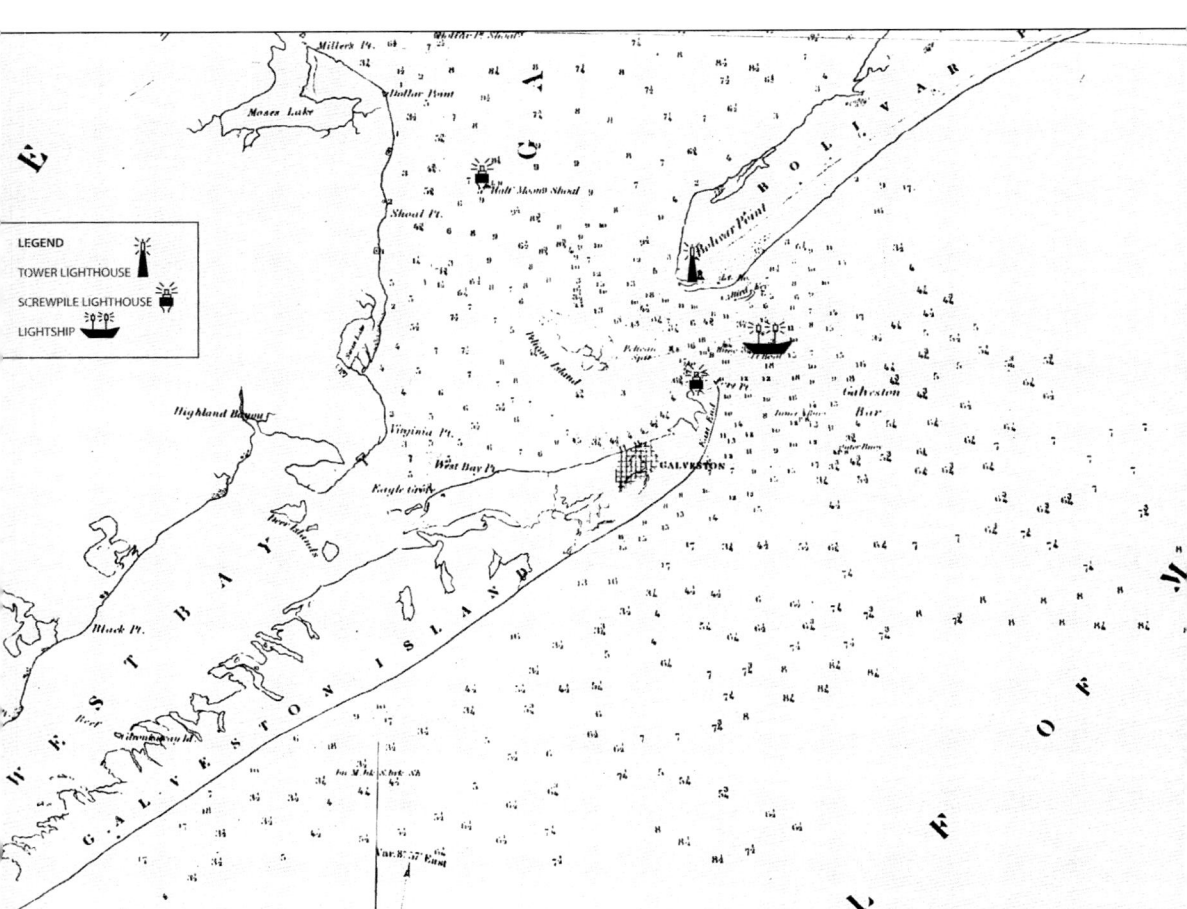

Texas's first navigational aids were lamps placed atop temporary wooden structures and maintained by the boat pilots who benefited most from them. After Texas was annexed to the United States, Congress began to appropriate money to build permanent lighthouses along its coast. Large brick or iron towers were erected at the larger ports; funds were allocated based on the importance and activity of each harbor, as well as the persistence of the local community in making requests for the lights. So-called "bug lights" were used in the bays and estuaries. These smaller wooden structures, built on iron piles sunk into the seabed, were usually constructed over water, where they resembled an insect skating over the surface—hence the name. This US Coast Survey map, dated 1855, shows the entrance to Galveston Bay and the positions of the lightship *Galveston* and the lighthouses on Bolivar Point, Fort Point, and Halfmoon Shoal. The lightship provided the first aid to navigation at Galveston Harbor. (Courtesy of the Texas General Land Office; lighthouse and lightship icons added by the author.)

The early lighthouses in Texas were equipped with oil lamps and had beams that were quite limited in range and intensity. Augustin-Jean Fresnel (pictured) was a French physicist and that country's commissioner of lighthouses. In the 1820s, he invented a method of building multipart lenses that could focus and project a light source for many miles. Soon, all lighthouses in the United States were equipped with Fresnel lenses.

The US Lighthouse Board displayed Fresnel lenses at expositions throughout the United States. This 1907 photograph shows the many different sizes of lenses that could be used in a lighthouse. Lenses were classified by order (size). The light from a huge first order lens could be seen for more than 20 miles. Most Texas lighthouses used the smaller third, "third and a half," fourth, fifth, or sixth order lenses.

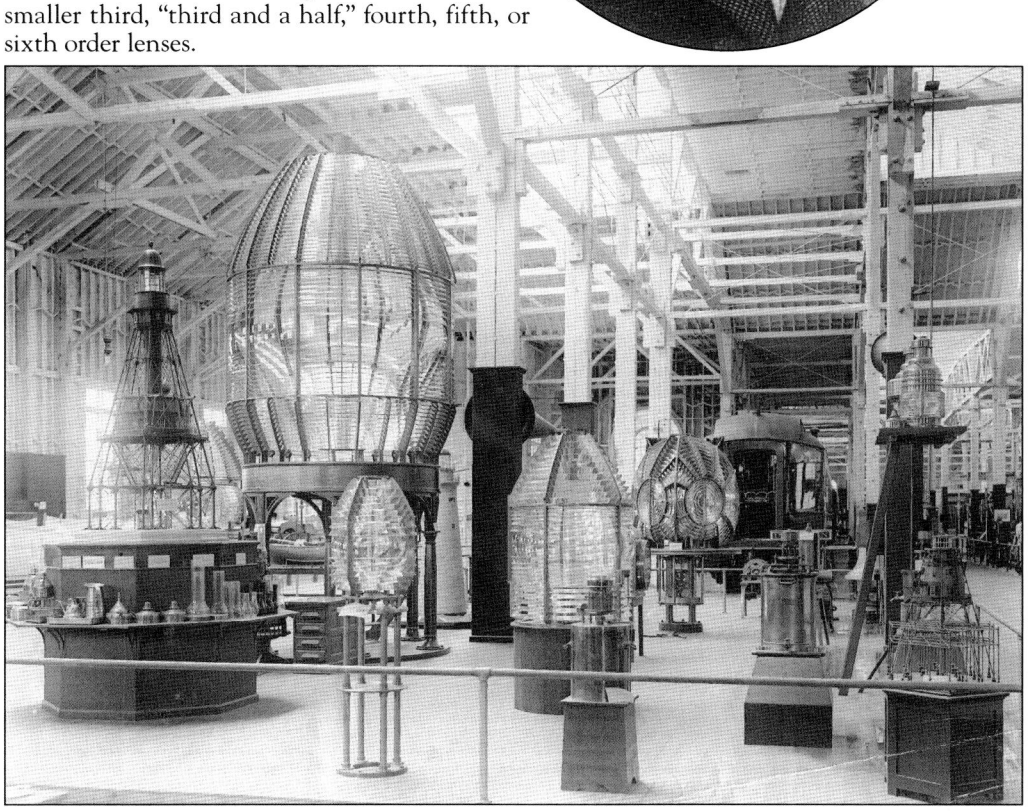

11

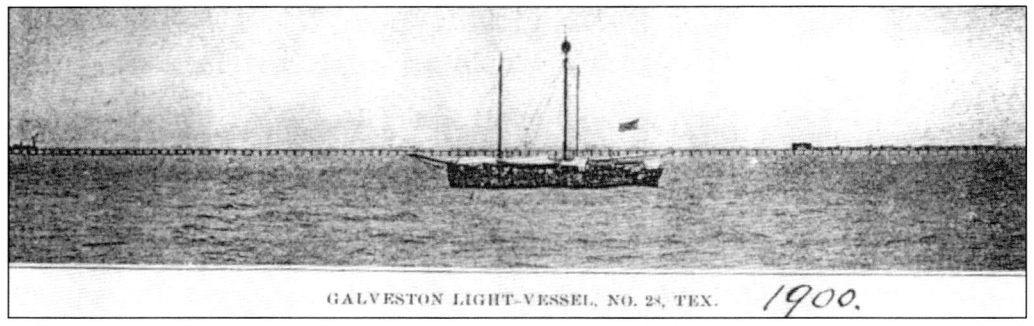

Galveston's first light was the lightship *Galveston*, built in 1849. *Galveston* was a wooden vessel, 90 feet long, with one lamp atop a mast. She was first anchored in the Gulf of Mexico, then moved well into Galveston harbor. After deteriorating for lack of regular repair, *Galveston* finally sunk while in port. She was replaced in 1870 by Lightship 28 (LV-28). After being discontinued in 1906, LV-28 served for several years as a barracks for local US Lighthouse Service personnel.

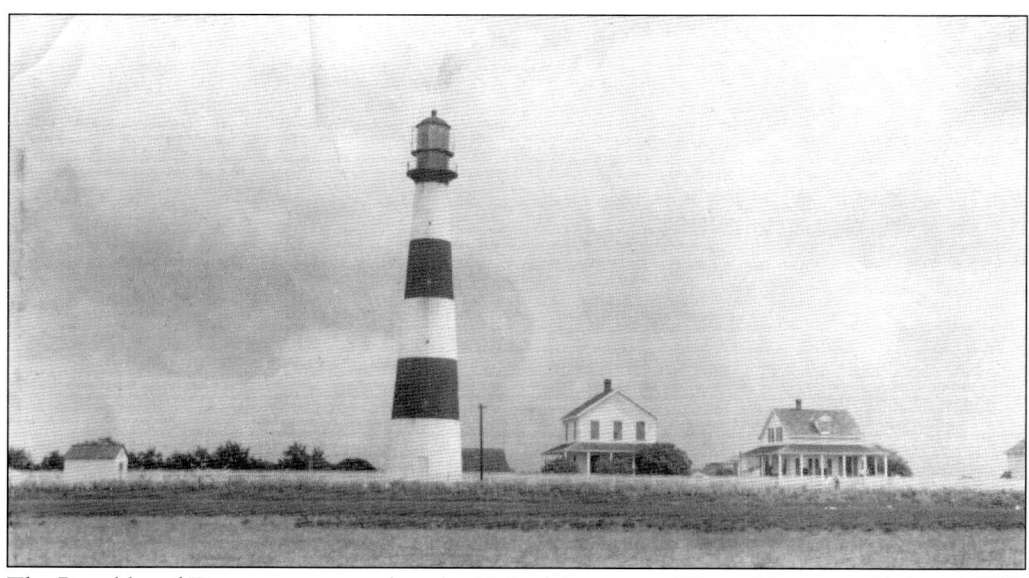

The Republic of Texas was annexed to the United States in 1845, and between 1847 and 1850, the US Congress authorized a total of $30,000 to build two lighthouses on the Texas coast. The first lighthouse built in the state of Texas was erected at Bolivar Point, near the southern tip of Bolivar Peninsula, in 1852; it was destroyed during the Civil War. This photograph shows its replacement, which was built in 1872.

In the late 1800s, Galveston was one of the most prosperous cities in the nation—so much so that it was known as the "Wall Street of the South." Downtown Galveston, sandwiched between the Gulf of Mexico and Galveston Harbor, was filled with impressive commercial buildings and grand houses. It was a major port for passengers and trade coming into Texas, as well as a resort city that lured vacationers from all over Texas to its wide sandy beaches. The sheer size of the Beach Hotel (below) gives a sense of Galveston's draw as a destination for sun and fun. (Both, courtesy of the Galveston Historical Foundation Preservation Resource Center.)

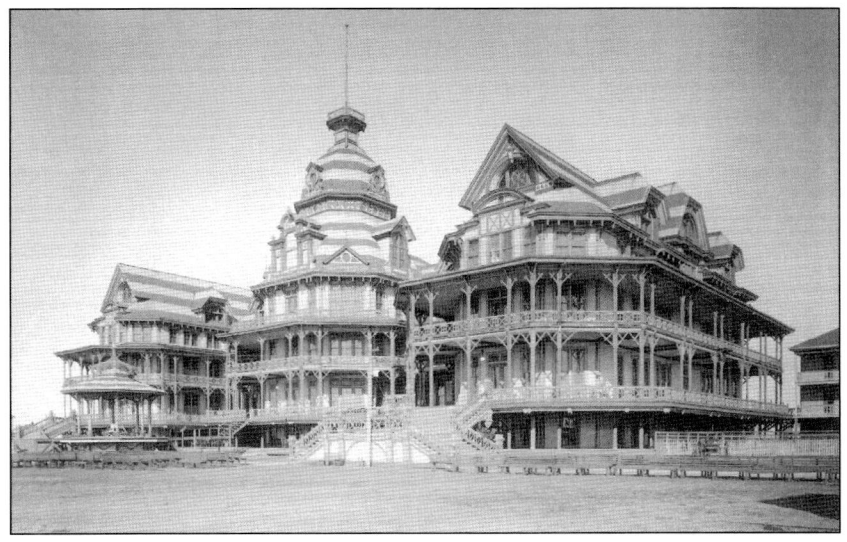

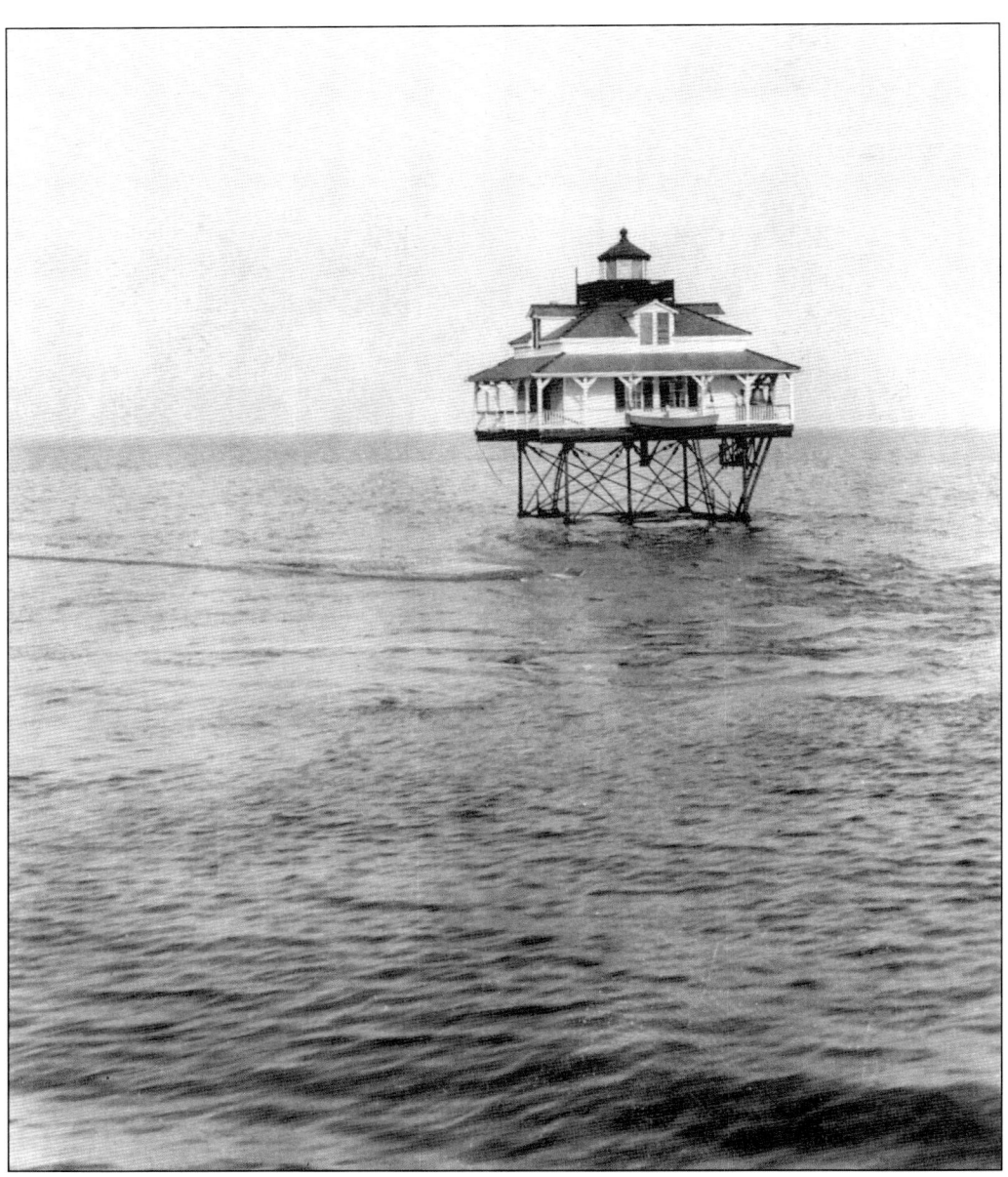

This 1925 photograph shows the third lighthouse built on Redfish Bar. The original 1854 lighthouse, located just off Smith Point, was destroyed by Confederate troops during the Civil War. Its 1868 replacement was battered by three decades of storms before it, too, had to be replaced. Constructed in 1900, this third lighthouse marked Redfish Bar Cut, a passage through the bar several miles away from the position of the original lighthouse. In all, 10 lighthouses in Texas bays were versions of this "screwpile" design. The construction of these types of lights involved driving wrought-iron piles with oversized screws on one end into the bottom of the bay, then building a wooden structure on top of the piles. Other lighthouses of this type were located at Clopper's Bar, Fort Point, and Halfmoon Shoal (Galveston Bay); East Shoal, West Shoal, Halfmoon Reef, and Swash Point (Matagorda Bay); and Brazos Santiago. This lighthouse remained in service until 1936, when it was dismantled.

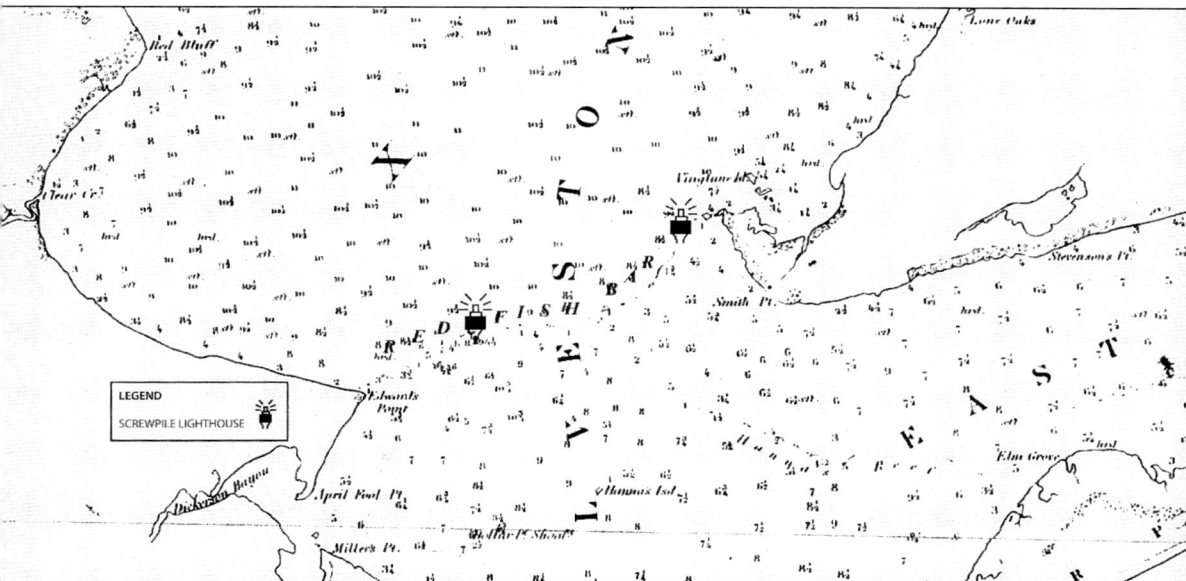

Redfish Bar, which long posed a hazard to navigation, was once an immense oyster-shell reef just southwest of Redfish Island. Redfish Bar extended from Edwards Point (now San Leon), on the western shore of Galveston Bay, across to Smith Point, south of Anahuac on the eastern shore. Because the bar was so dangerous, a cut was made in it to aid boaters and shipping. Beginning in 1905, oyster shell was mined from the bay for use in street paving, construction projects, and chemical manufacturing. The volume of shell removed from Galveston Bay was so great that it would have covered an estimated 135,000 acres at a foot deep, and all of Redfish Bar was taken. Redfish Island—no longer protected by the bar—was lost to Hurricane Alicia in 1983, although the US Army Corps of Engineers has used dredging spoils from the Houston Ship Channel to reconstruct an ersatz island that bears the same name. (Courtesy of the Texas General Land Office; icon and type added by the author.)

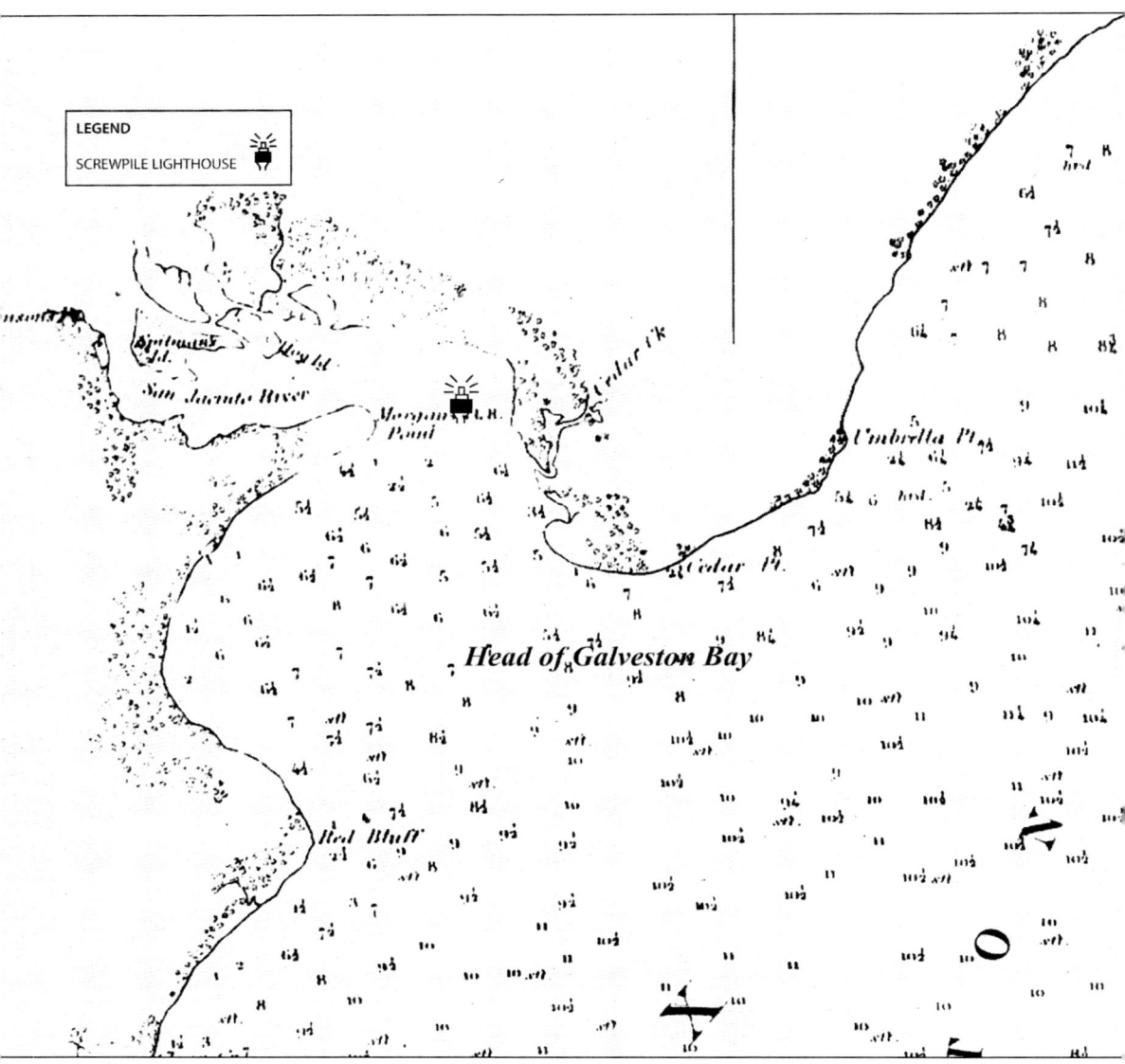

Clopper's Bar was one of three screwpile lighthouses built in Galveston Bay in 1854. It had a fixed sixth order lens to help guide boats across the bar at the head of the bay and into the San Jacinto River and Buffalo Bayou. The light was discontinued but undamaged during the Civil War. It was relit in 1868, but discontinued again in 1880 and eventually abandoned. The Houston Ship Channel was later dredged through that general area. In the 1870s, the lighthouse keeper and assistant were a married couple named John and Catherine Smith. It was not uncommon for wives to work as assistant keepers, and some women became head keepers themselves. Hannah Ham became an assistant to her husband at Point Isabel in 1853 and was appointed head keeper after his death in 1860. She served until the light was extinguished in 1861. Lillie Ahern was a keeper at Redfish Bar from 1889 to 1892. Lydia Roberts served at Aransas Pass from 1908 to 1921. (Courtesy of the Texas General Land Office; icon added by the author.)

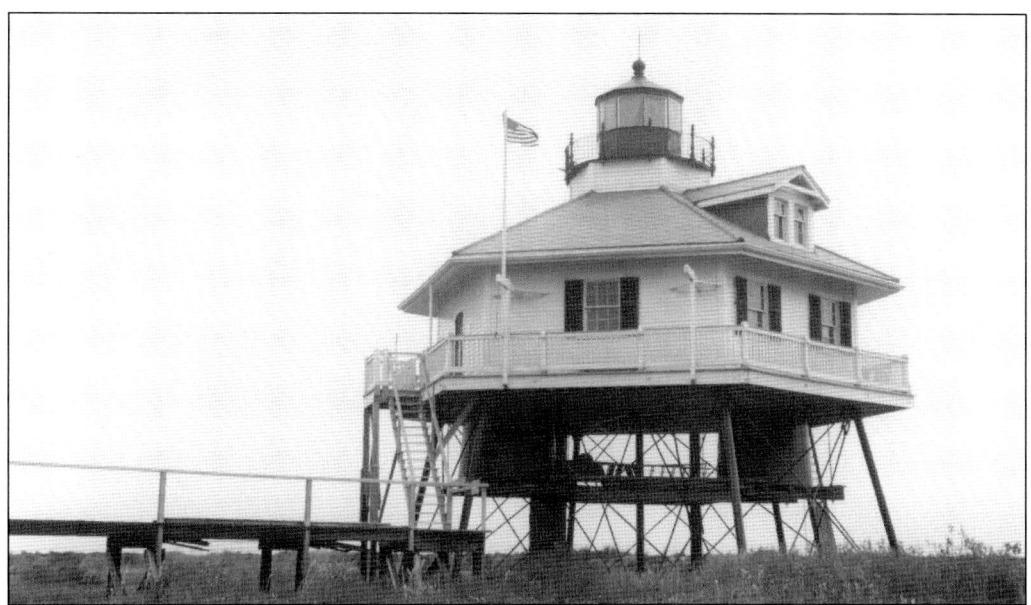

The Fort Point lighthouse was built on Galveston Island in 1881 or 1882 near a site that would become Fort San Jacinto nearly 20 years later. The light it exhibited was white with two red cuts, so that as a vessel approached the lightship, turning buoy, and wharves, the color would change. The red cuts were adjusted after the lightship was discontinued and jetties were built.

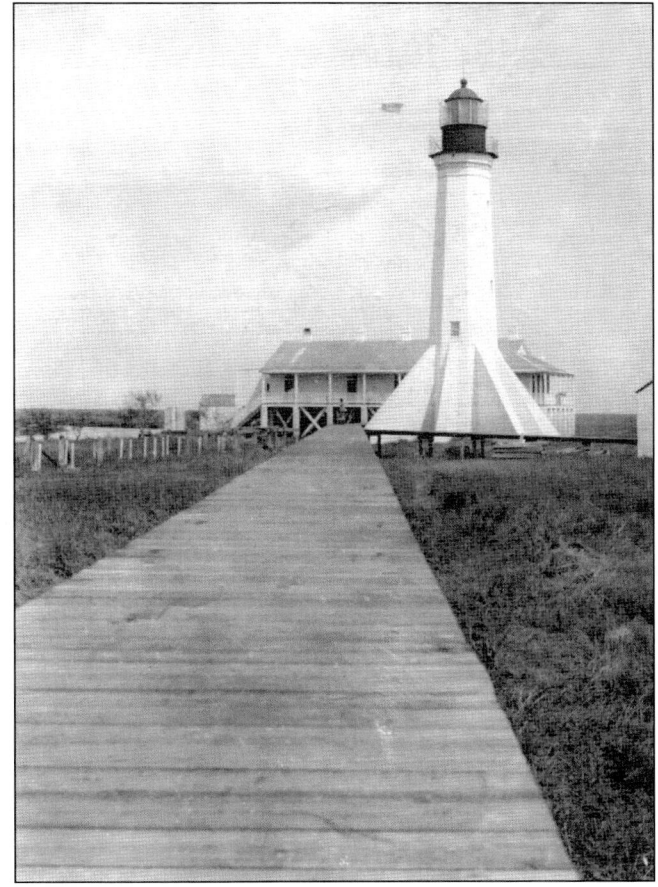

No one questioned the need for lighthouses around Galveston, but the Sabine River, near the Louisiana border, was a different story. Although Congress appropriated funds for a lighthouse in 1849, officials disagreed about whether a lighthouse was needed there at all. The Sabine Pass lighthouse (pictured), built in 1857, has an unusual design that includes buttresses to spread its weight over the soft, sandy soil. The lighthouse was painted white and had a third order lens.

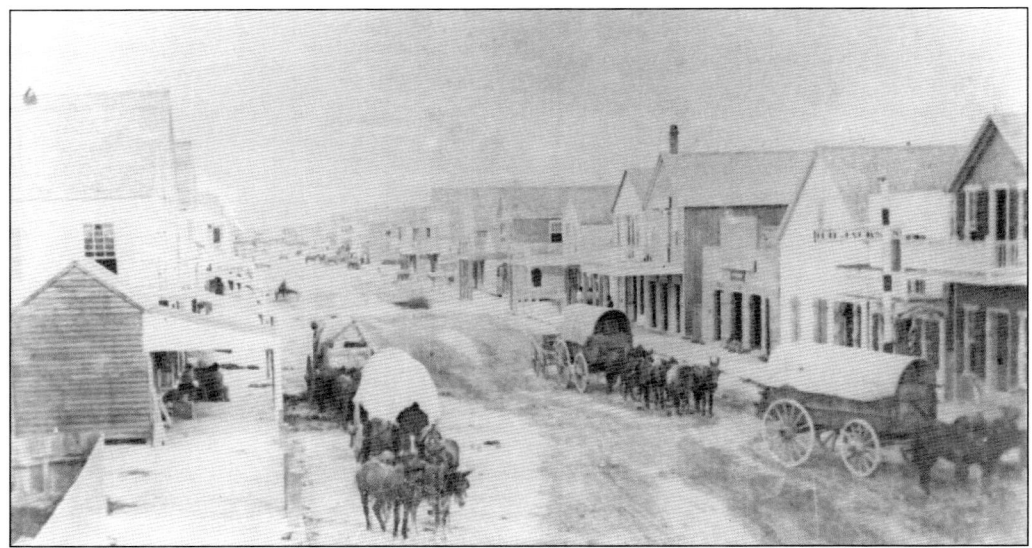

Galveston was not the only city vying for the role of primary port in Texas; although Indianola was eventually destroyed by a hurricane in 1886, it was once a serious competitor. Located just inside Matagorda Bay, Indianola provided a direct route to Central Texas and enabled passengers to avoid travel through the swampy Harrisburg/Houston area and, consequently, its regular outbreaks of mosquito- and water-borne diseases. (Courtesy of the Calhoun County Museum.)

In the mid-1800s, Indianola was thriving. European immigrants by the thousands arrived via the Morgan Steamship Lines, which shipped cattle and cotton out of Texas as fast as they brought people in. Railroads moved people and cargo to and from the port. This activity helped to encourage the development of other cities around the perimeter of Matagorda Bay, including Port Lavaca, Palacios, and Port O'Connor. (Courtesy of the Calhoun County Museum.)

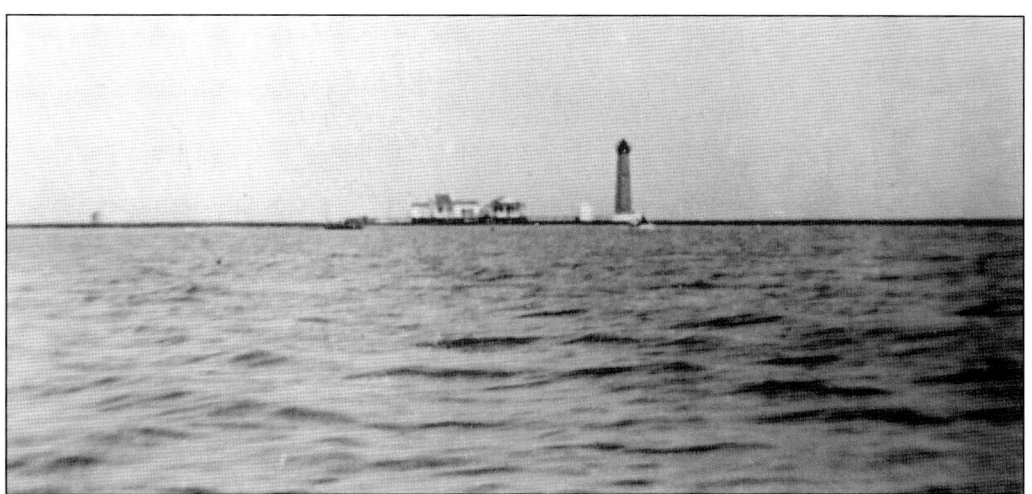

With so much traffic on Matagorda Bay, pilots clamored for navigational aids. The second lighthouse built in Texas was on the east end of Matagorda Island. It was completed in 1852, a few months after the lighthouse went up at Bolivar Point, and made of prefabricated cast-iron plates, bolted together on site, and painted in white, red, and black horizontal bands. (Courtesy of the Victoria Regional History Center, Victoria College/University of Houston-Victoria Library.)

In 1858, the Matagorda Island lighthouse was raised and refitted with a third order lens. Hurricanes and gales regularly damaged the structure; wind and water eroded the ground under its foundation. After it was damaged by Confederate forces during the Civil War, the remnants were removed. This map shows the location of the original lighthouse (directly above the words "Ship Channel"), described as "foundation of iron tower torn down."

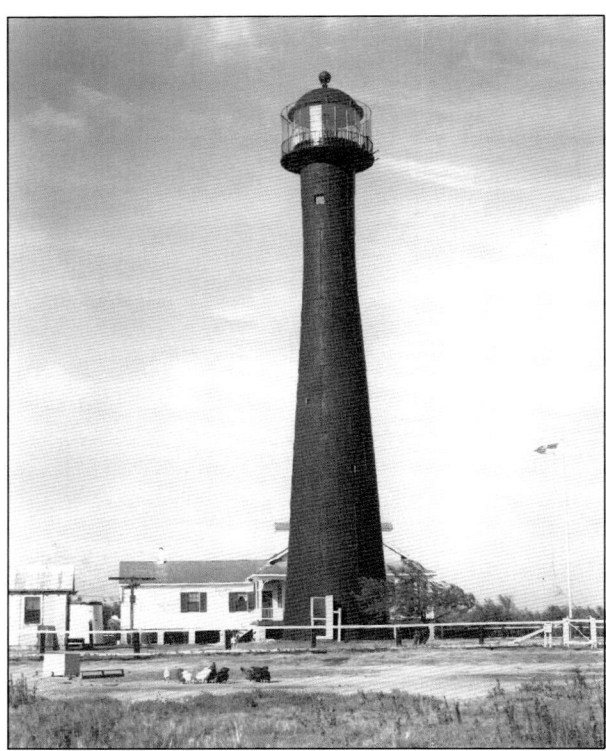

The post–Civil War Matagorda Island lighthouse, pictured here, was built two miles from the original location. It reused many of the cast-iron plates from the original structure, which had been stored "on the highest point of the island" while new plates were made to replace those broken during the war. A third order lens was installed, and the light was exhibited for the first time in September 1872.

The new lighthouse was built on a 10-acre site and included a keeper's cottage that was also built in 1872. Two acres were enclosed with a picket fence. Only the tower, the house, and the fence survived an 1886 hurricane that destroyed everything else on the property. A new assistant keeper's house, stable and washhouse, and cypress cisterns were constructed, and storage for emergency supplies added to the tower.

Lighthouse keepers not only maintained lighthouse lights; they were also responsible for the many range lights and beacons positioned throughout the Gulf and bays. In some cases, a single keeper might have as many as 30 or 40 lights to check and maintain. US Lighthouse Service (later US Coast Guard) tenders such as this one, assigned to Matagorda, were used to make those rounds and to transport keepers and provisions to and from the lighthouse.

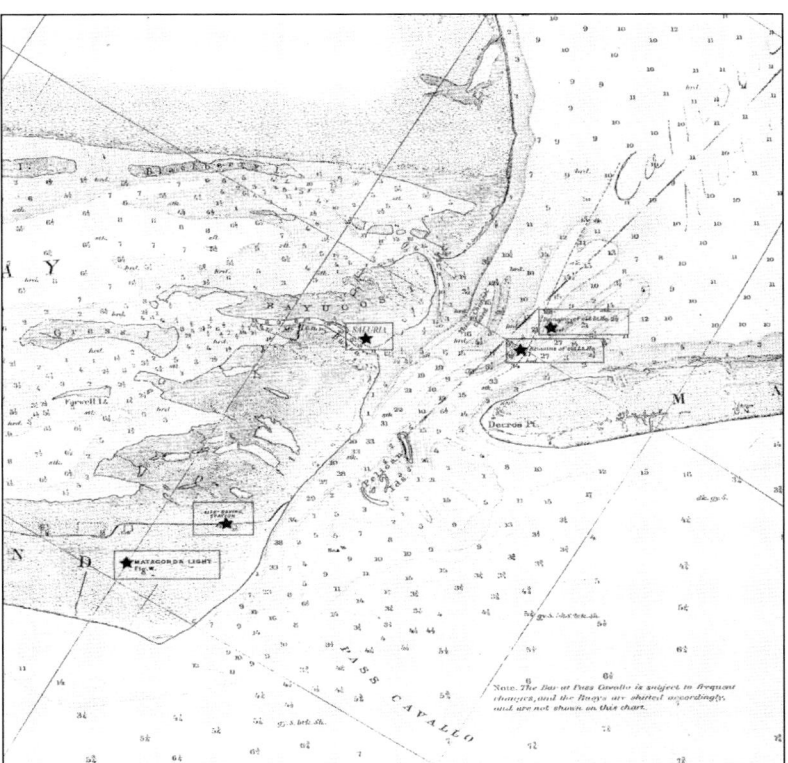

This 1888 map shows the location of the new Matagorda Island lighthouse, as well as the remains of the East Shoal, West Shoal, and Saluria lighthouses. The Matagorda Life-Saving Station is also indicated. Between 1852 and 1888, lighthouses were built in seven different locations near Matagorda Bay. (Courtesy of the Texas General Land Office.)

21

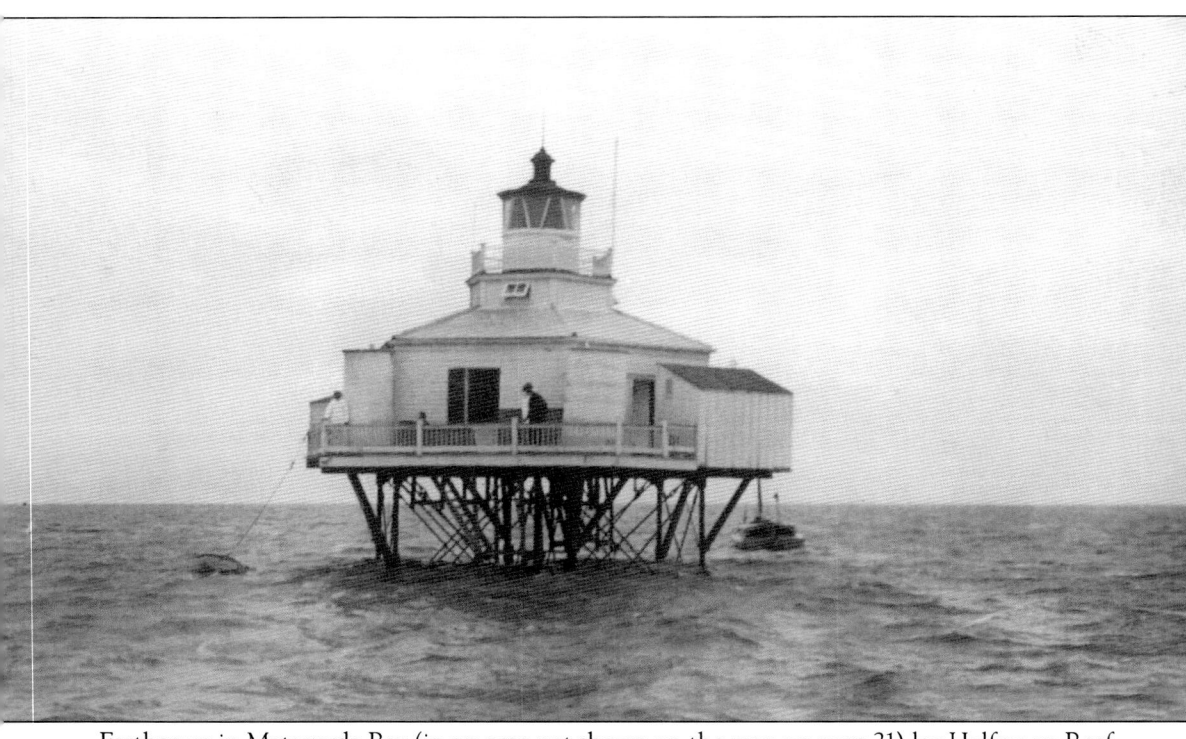

Farther up in Matagorda Bay (in an area not shown on the map on page 21) lay Halfmoon Reef, a massive underwater oyster reef that separated Matagorda and Palacios Bays. Not long after the construction of the original Matagorda Island lighthouse, bay communities asked for another lighthouse to mark Halfmoon Reef. The request was granted in 1855, and construction began in 1858. The Halfmoon Reef lighthouse was an exact copy of the Wades Point lighthouse in North Carolina. Halfmoon Reef exhibited a sixth order lens until 1942, although the light was extinguished on at least two occasions, and the station was frequently considered "not worth repairing" and was periodically unmanned. When this photograph was taken in 1919, the light had been upgraded to a fourth order lens; then-keeper George W. Anderson may be one of the people shown in the photograph.

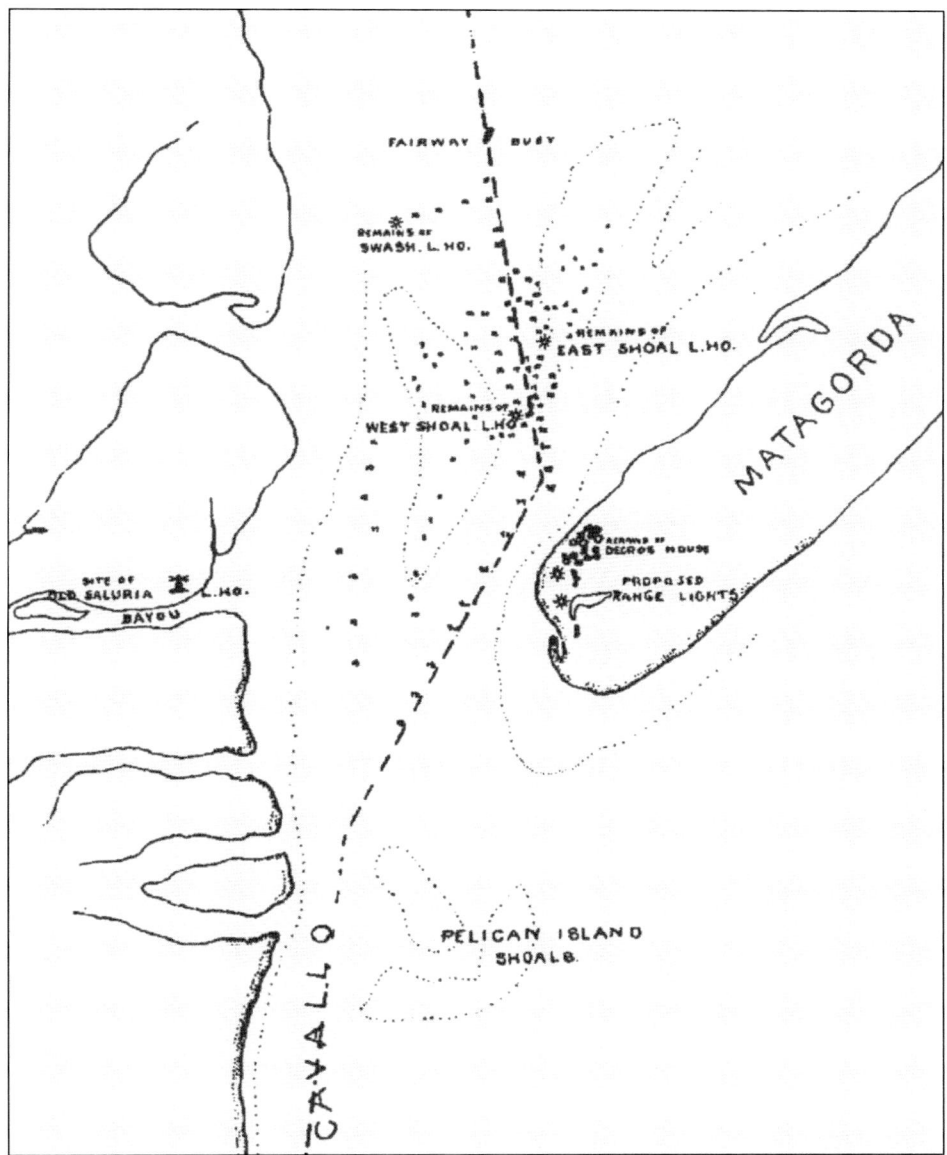

This map shows three other screwpile (or "bug") lighthouses built in Matagorda Bay. Swash Point, opposite Alligator Head, was the first, constructed in 1858. That light was extinguished by Confederate forces during the Civil War; its fifth order lens was removed and placed into storage in 1861. Although it was reportedly in good condition at that time, the lighthouse had been destroyed by 1863; by 1868, only the screwpiles remained. The US Lighthouse Board allocated $15,000 to rebuild but ultimately decided that the light station should be located at Decros Point, closer to Pass Cavallo at the mouth of the bay. However, that plan was abandoned when the land's owner refused to sell. In 1871, two screwpile lighthouses were built one-half mile apart to mark the bay's entrance. The West Shoal light, closer to the Gulf, was red, while the East Shoal light was white. Only a few years later, the 1875 hurricane destroyed both lighthouses. The lighthouses' keepers—John Hicks and his assistant, Jacob Hall, at West Shoal; Thomas Mayne and his assistant, Edward Finck Jr., at East Shoal—also lost their lives in the storm.

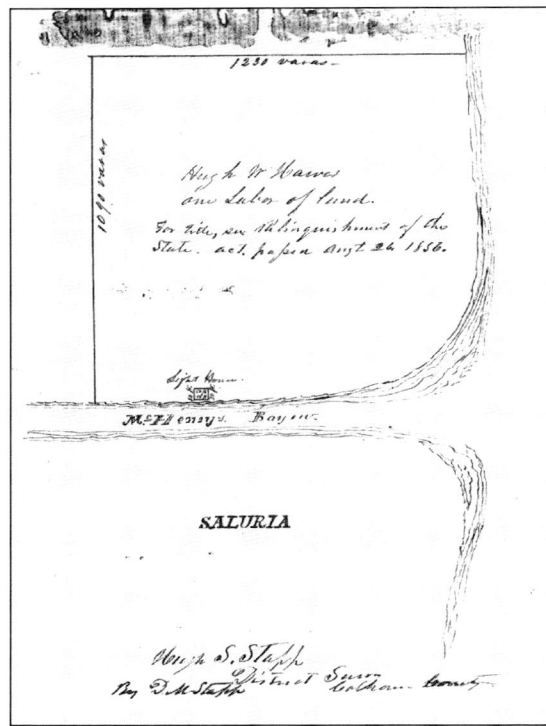

Because large ships could not navigate Texas's shallow bays, "lighters" (flat-bottomed barges) were used to move people, cargo, and mail to inland ports. Across Matagorda Bay from Decros Point, there was a harbor for lighters, bay craft, and steamboats at the mouth of McHenry's Bayou. A town called Saluria developed on the south side of the bayou; a wooden skeleton tower lighthouse with a sixth order lens was constructed on the opposite shore in 1858. (The base of the tower was an oil storage room, not a keeper's residence.) During the Civil War, the townspeople fled, fearing a Union invasion; Confederate troops from nearby Fort Esperanza set fire to the town and took down the lighthouse. Some residents returned after the war ended, but Saluria was devastated by the hurricane of 1875 and was later abandoned. The lighthouse was never reestablished.

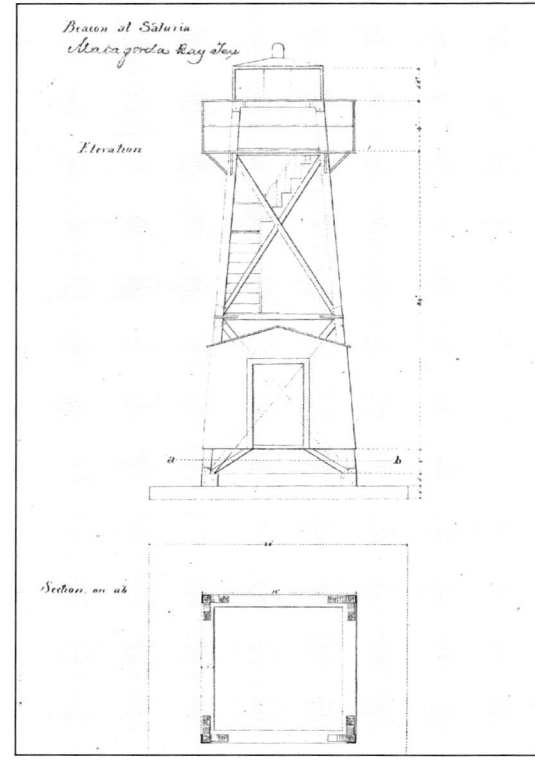

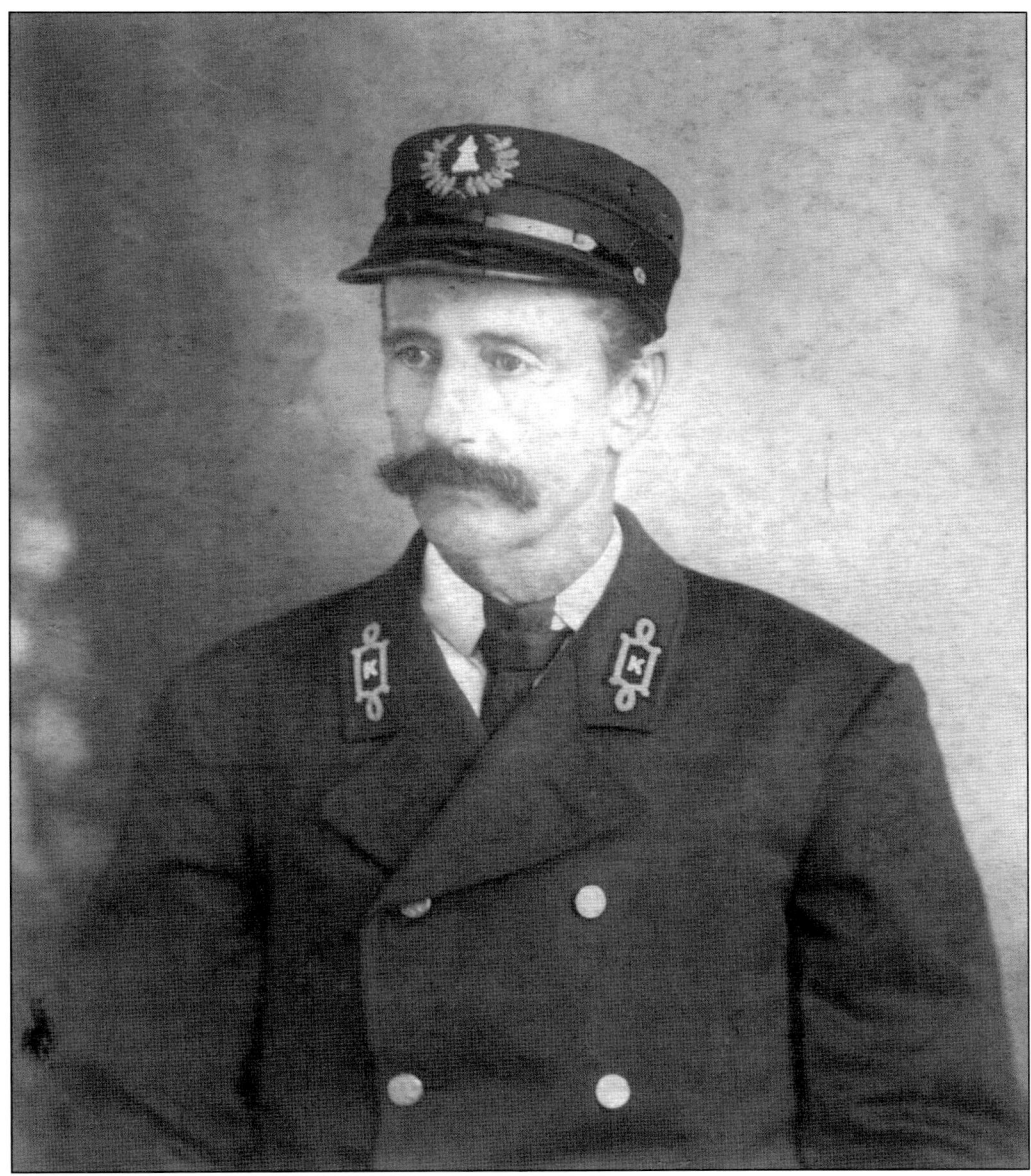

This rare photograph is of lighthouse keeper Stephen Decatur Hill. Born in Baltimore, Maryland, in 1849, Hill was a sailor who came to Matagorda around 1880 with his young wife, Josephine Ainsworth Hill, and their first child. They were still living in Calhoun County in 1900, along with Hill's younger brother Phillip, also a sailor. Stephen Hill became a lighthouse keeper and was stationed at Halfmoon Reef from 1903 to 1905 and at Sabine Pass from 1906 to 1912. The Hills raised at least a few of their six daughters (Maude, Susie, Bertie, Sadie, Florence, and Fannie Jay) at lighthouses. Two of the girls married assistant lighthouse keepers, according to Hill's grandchildren, Grace Reeves and Charles O'Brien. Florence's wedding to assistant keeper Henry C. Clausen took place at the Sabine Pass lighthouse in 1909. Stephen Hill died in 1913 in Port O'Connor, Texas. (Courtesy of Corpus Christi Public Libraries.)

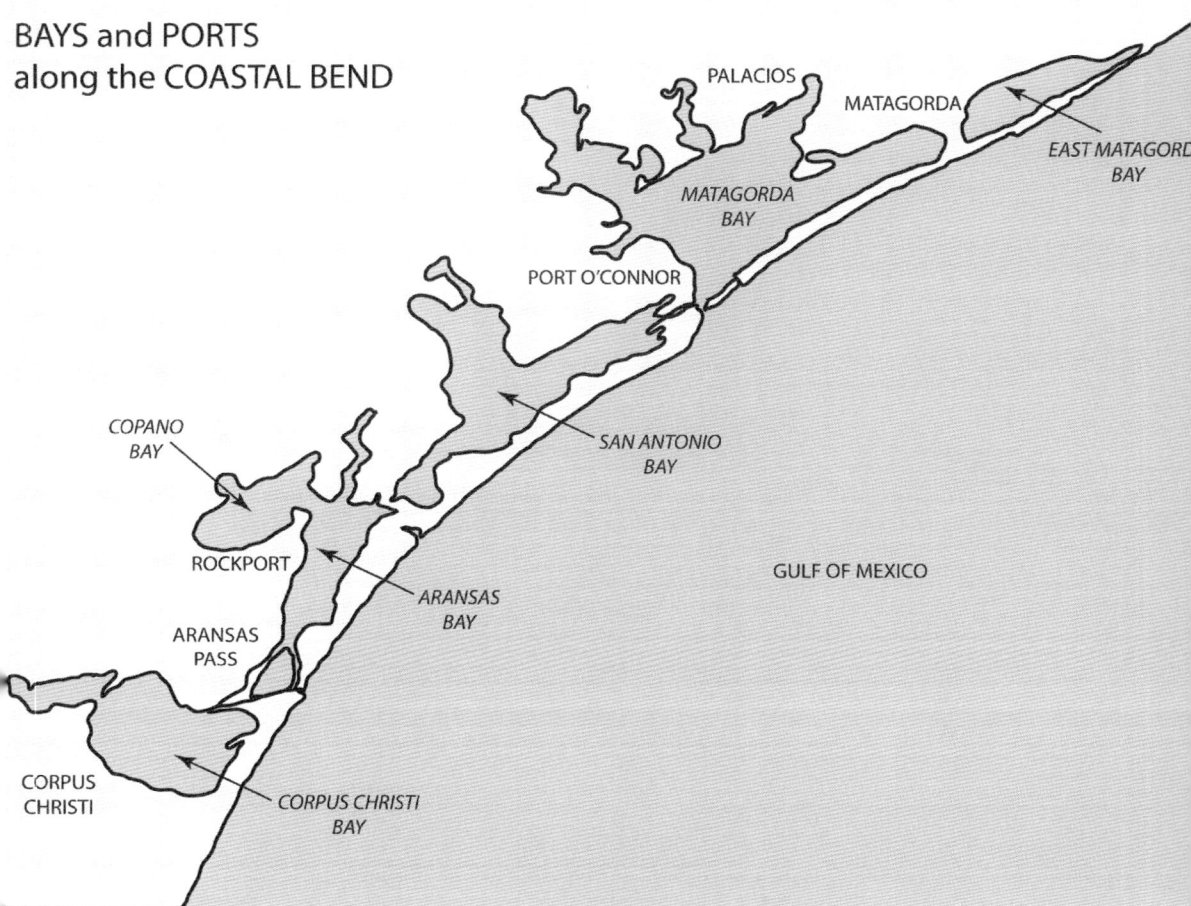

Matagorda Island shelters three major bays—East Matagorda, Matagorda, and San Antonio—as well as many smaller ones. Continuing south past Matagorda, St. Joseph Island (also known as San Jose) and Mustang Island flank either side of Port Aransas. The split between those islands, known as Aransas Pass, officially divides Aransas Bay and Copano Bay (behind St. Joseph Island, to the north) from Corpus Christi Bay (behind Mustang Island). Lighthouses were needed to help boats reach Port O'Connor, Port Lavaca, and Palacios, all shipping points inside Matagorda Bay that moved passengers and goods to and from the Texas interior. In Aransas Bay, however, communities like Rockport, Fulton, and Port Aransas are all located close to Aransas Pass, and only one lighthouse was needed to mark the pass. The channels in and around the pass were marked with beacon lights. (Map created by the author.)

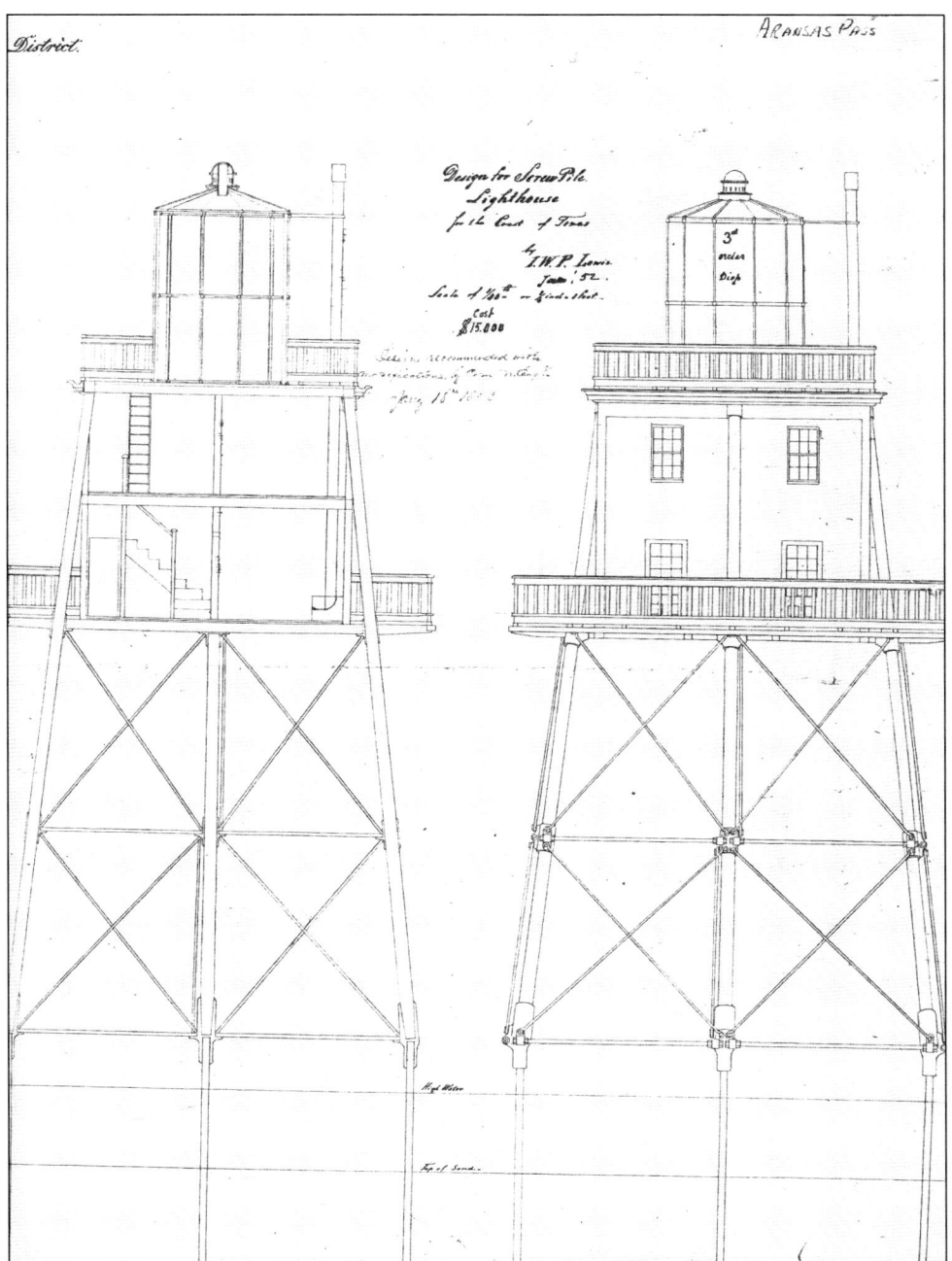

This was the first set of plans developed by I.W.P. Lewis for the Aransas Pass lighthouse; Lewis designed many of the screwpile lighthouses in the Florida Keys. This design was not built, nor was a second screwpile design. While the US Lighthouse Board deliberated the design (and even considered a lightship instead), the pass moved five miles in a single year. Barrier islands are constantly changing and moving as waves and wind carry sand in a southerly direction down the coast. This movement continued to affect the Aransas Pass lighthouse and ultimately led to its abandonment.

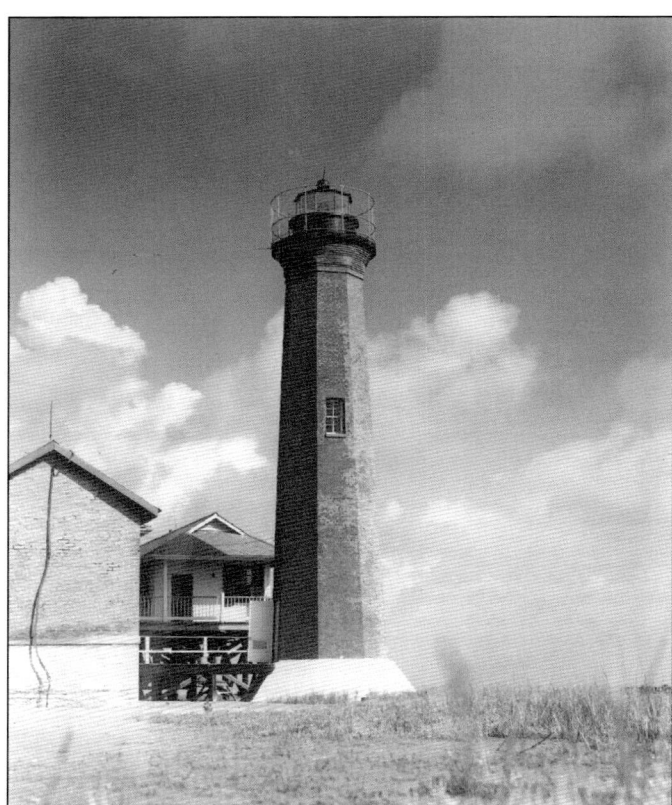

The US Lighthouse Board spent several years scouting for an appropriate location for the lighthouse at Aransas Pass. In 1855, it finally purchased a 25-acre site on Harbor Island, just inside the pass. The lighthouse was built of brick, 55 feet tall with an octagonal shape, with walls four feet thick. The tower was topped by a fourth order lens.

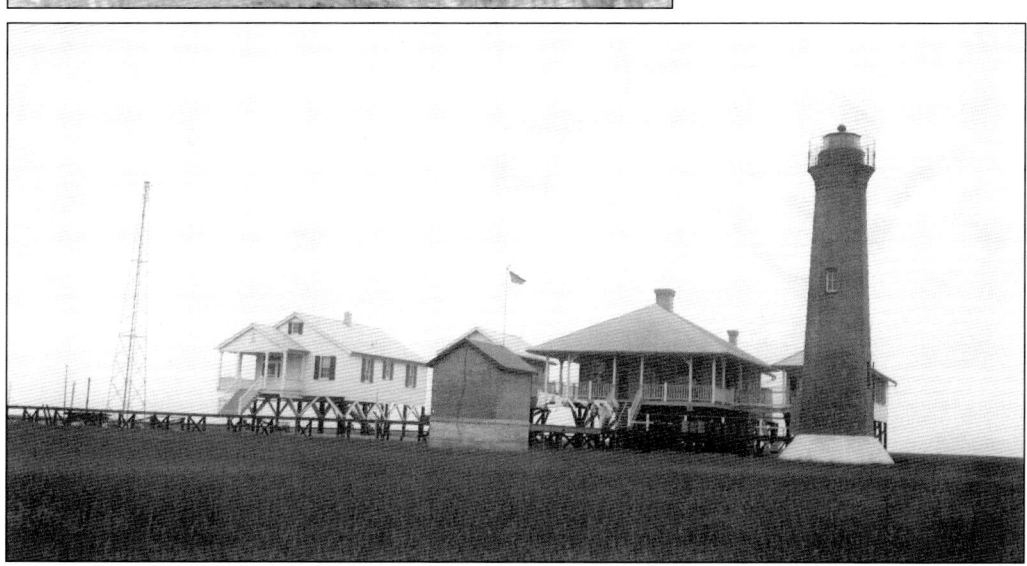

These buildings were the third set constructed at the location on Harbor Island. The original keeper's dwelling and other buildings were damaged during the Civil War, and the old assistant keeper's cottage was destroyed during the 1919 hurricane. The replacements were built to last—each was on 20 cast-iron columns, set into a foot of concrete, and had walls made of hollow tile covered in stucco.

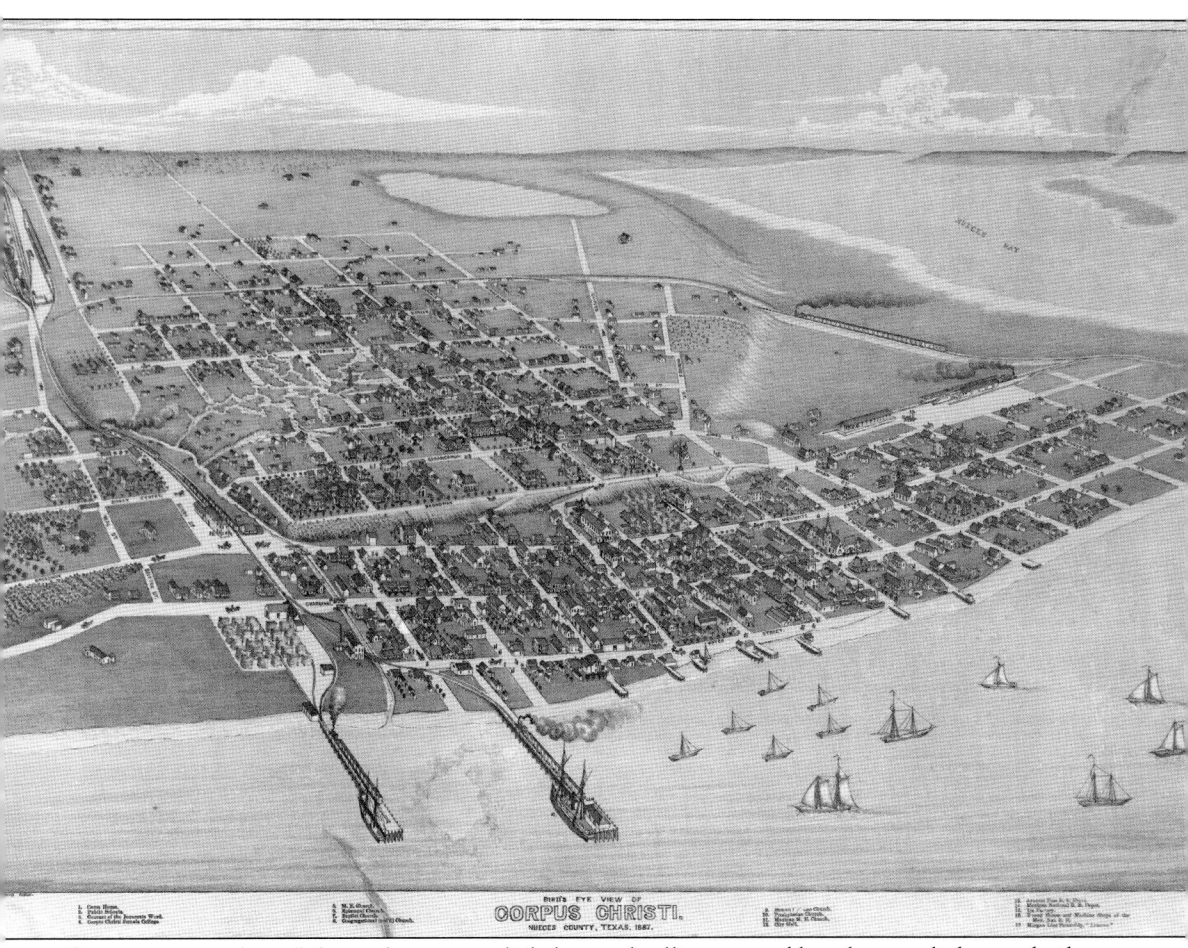

Continuing southward down the coast, a lighthouse dwelling topped by a beacon light was built in Corpus Christi around 1859. It was abandoned within the year due to the poor condition of its brick walls, which were failing due to shifting ground beneath the foundation. The building was used as a storage room for ammunition during the Civil War, and it was further damaged during that time. Various accounts of attempts to destroy the arsenal include a Union bombardment, explosive charges set by Confederate troops, and a group of boys with a butter churn full of gunpowder. At any rate, the lighthouse was in ruins by 1870 and was abandoned. In 1878, it was declared a nuisance and subsequently dismantled by a city alderman, Dick Jurdan. Located at Buffalo and Broadway Streets, it would have been in the center of this 1887 map. (Courtesy of Corpus Christi Public Libraries.)

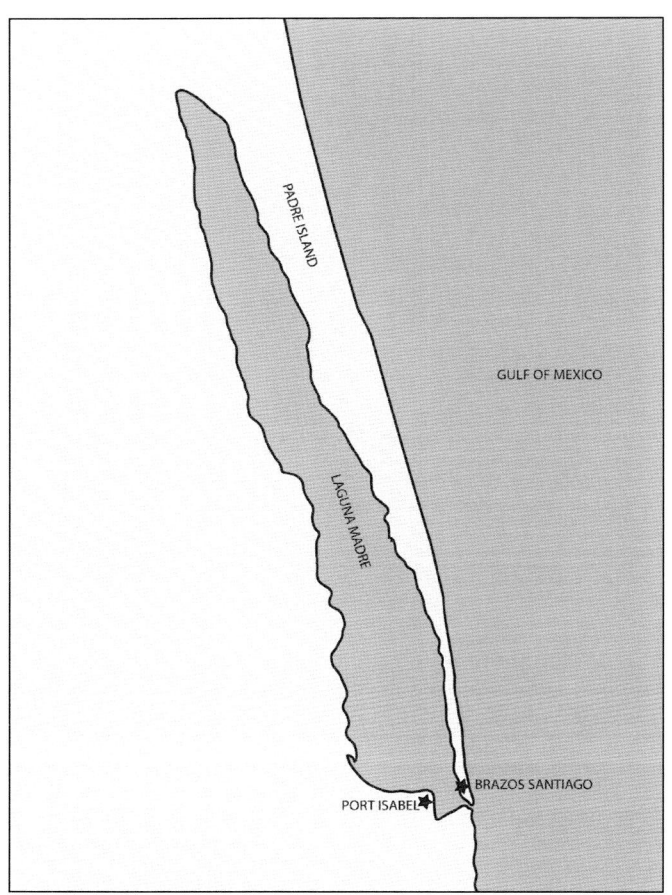

Padre Island is the southernmost barrier island in Texas. At 70 miles long, it is also the longest undeveloped barrier island in the world. The island shelters Laguna Madre, one of only six hypersaline (saltier than the ocean) coastal lagoons in the world. Together, the island and lagoon make up a protected National Seashore. (Map created by the author.)

Two lighthouses were located near Padre Island—the Port Isabel (formerly Point Isabel) lighthouse is on the mainland, and across Laguna Madre, the Brazos Santiago lighthouse was just off the tip of South Padre Island. This photograph of the Port Isabel Lighthouse might have been taken from the old causeway that connected the island to the mainland.

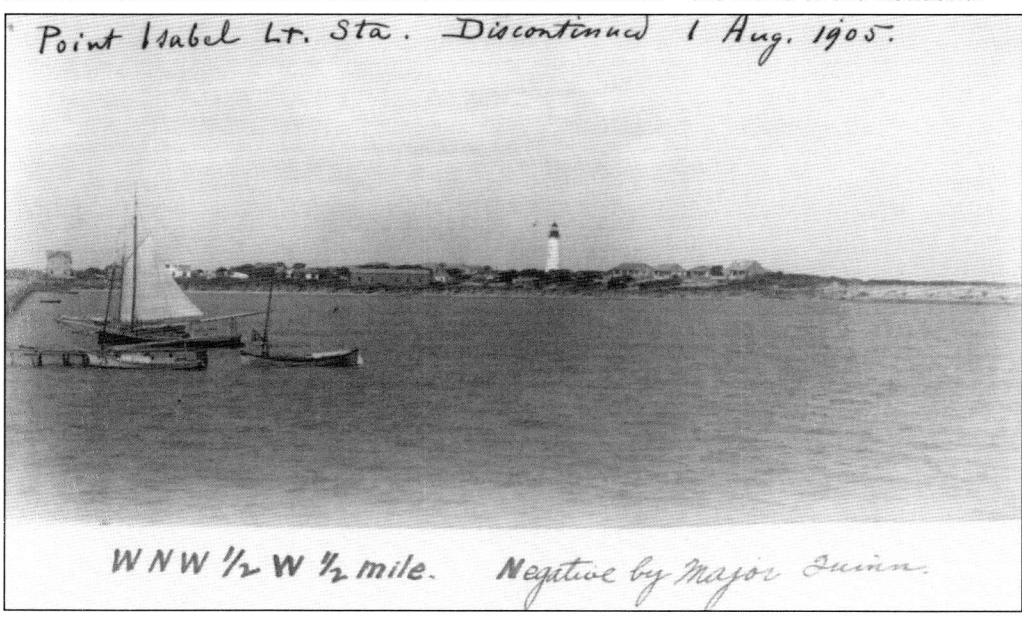

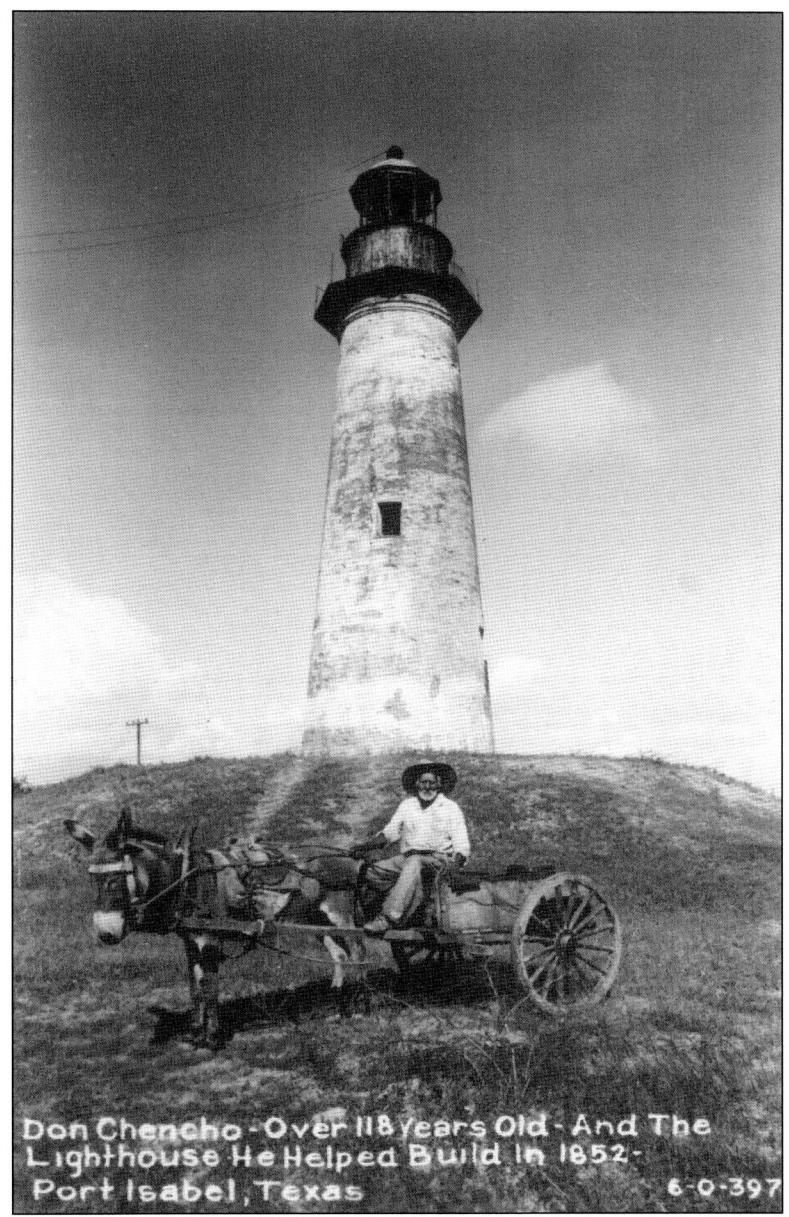

Don Chencho - Over 118 Years Old - And The Lighthouse He Helped Build In 1852 - Port Isabel, Texas 6-Q-397

Initial plans would have placed the lighthouse on Padre Island due to its proximity to the Gulf of Mexico (compared to Point Isabel, which was nearly three miles away). Inspectors determined, however, that the island was too sandy and prone to flooding during high tides, so it would be difficult to built a suitable foundation there for the lighthouse. Locals agreed, and John Rhea, the Point Isabel customs collector, suggested that the lighthouse should be built at the former site of Fort Polk, 30 feet above sea level. Construction on the Port Isabel lighthouse began in 1852, but it was not completed and lit until April 1853. According to Rhea, "The building can be erected at Point Isabel of brick cheaper than any material owing to the very reduced price of Mexican labour." One of those workers, Don Chancho, is pictured here with the lighthouse that he helped build.

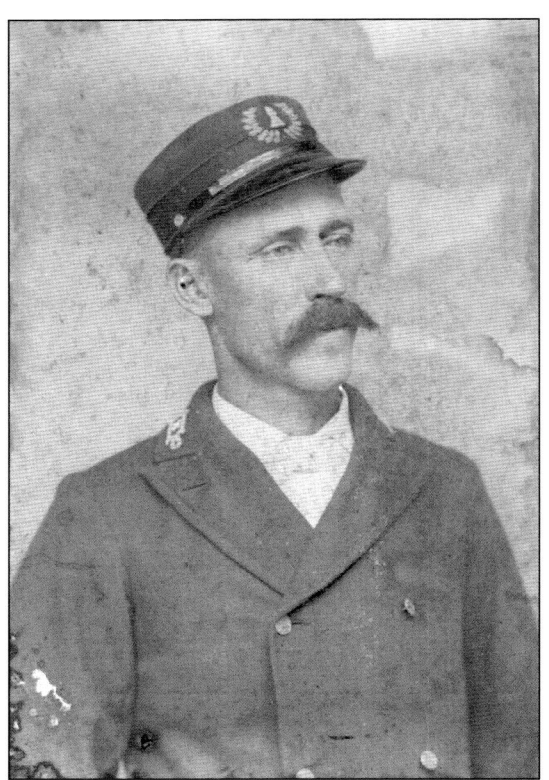

This photograph of a lighthouse keeper is identified as being from Port Isabel in the early 1900s. If that is correct, this would be head keeper William Egly, who served at Port Isabel from 1895 to 1905. He had previously been stationed at Aransas Pass. (Courtesy of DeGolyer Library, Southern Methodist University, Dallas, Texas, Lawrence T. Jones III Texas Photography Collection, Ag2008.0005.)

Originally built with a third order lens, the Port Isabel lighthouse was damaged during the Civil War and repaired with a fifth order light. It was abandoned in 1888 but reestablished in 1895 after much public outcry. The lighthouse was discontinued again in 1905 and sold to a private owner in 1927 (he is possibly pictured in this 1936 image). (Courtesy of the Victoria Regional History Center, Victoria College/University of Houston-Victoria Library.)

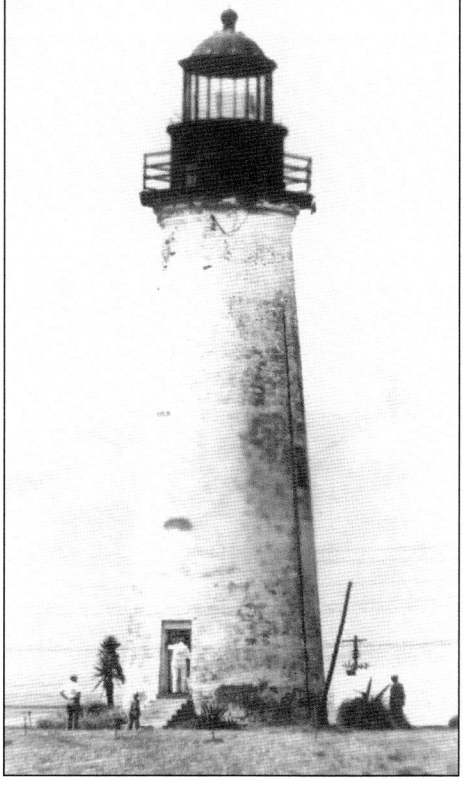

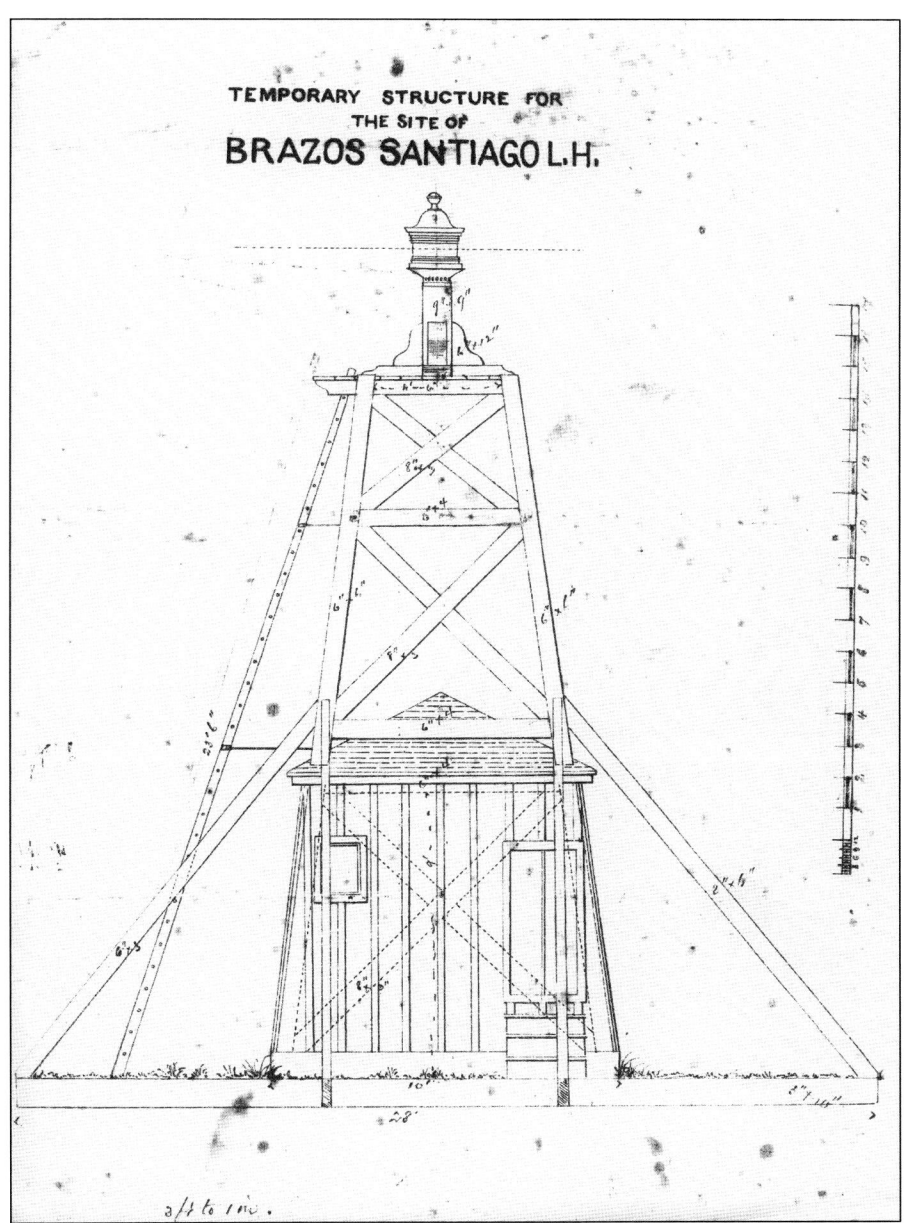

Across the Laguna Madre, a secondary beacon was needed at the southern end of Padre Island. In an 1851 letter to customs collector John Rhea, local pilot Thomas King wrote, "The beacon required on Padre Island is a moveable one, placed on wheels, say a mast thirty feet high on a frame . . . with signal haulyards to hoist a flag on by day or a lantern by night, wherever the pilots can make it available . . . The pilots would always make sure that it is properly placed." Rhea wrote back, enclosing a plan for a lantern that could be run up and down between two posts "by means of weights and small wire ropes." The request was approved and bids were solicited for construction. The resulting structure was much more robust than the one Rhea proposed, as shown in this c. 1853 plan. The tower was topped with a three-foot-tall copper lantern containing a fifth order lens.

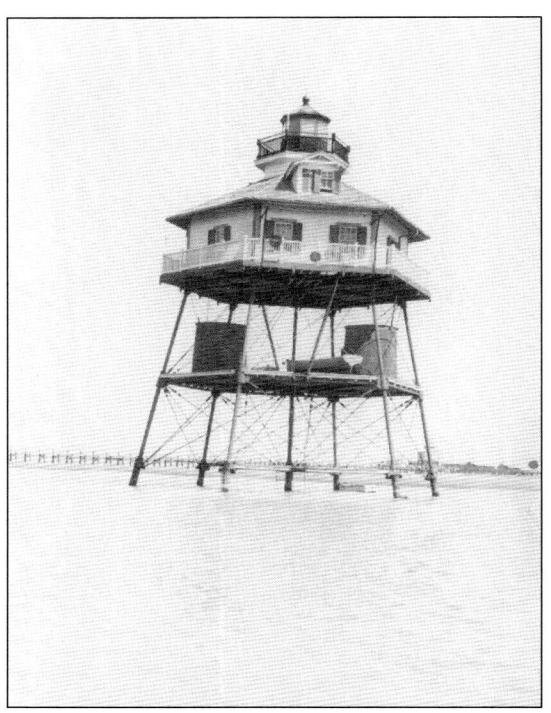

After the Padre Island Beacon tower was destroyed during the Civil War, a series of temporary wooden towers were built until this permanent structure, known as the Brazos Santiago lighthouse, was completed in 1879. The oil tanks shown on the lower platform in this 1926 photograph were replaced by a generator and battery room by 1937. (Photograph by assistant superintendant A.M. Zibilich.)

Eventually, the Brazos Santiago screwpile lighthouse was replaced by this modern Light Station, which was built in 1943 and is pictured here in 1948. This is typical of a Coast Guard station built in the mid-20th century, when more powerful lamps were available, which allowed for a smaller light beacon.

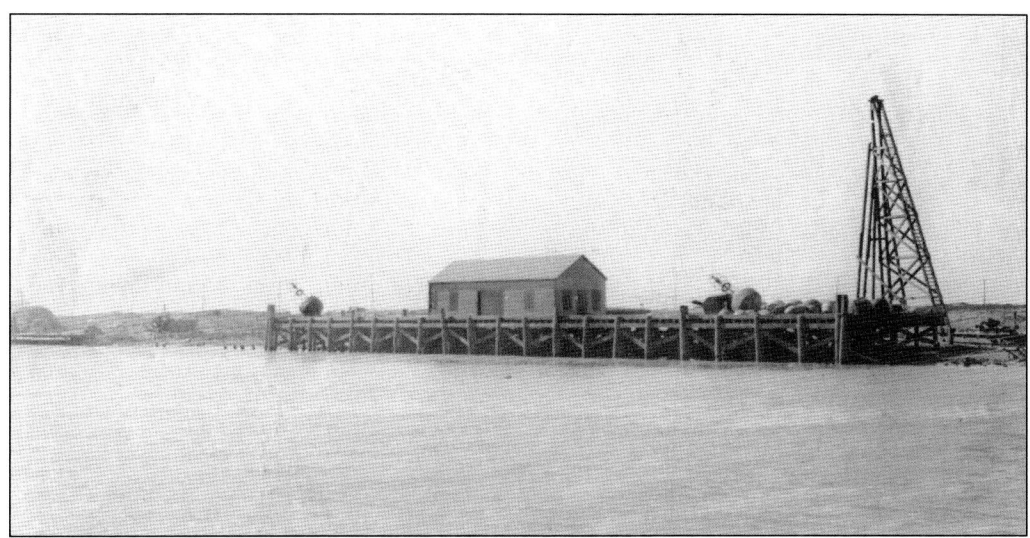

The Galveston Lighthouse Service depot, shown above in 1923, served all of the Texas coast. The service maintained many navigational aids in addition to the lighthouses; in relatively shallow water, such as harbors and bays, these included lighted beacons (lights mounted on piles or other structures) and unlighted day beacons or daymarks. At sea, large buoys were used to mark shipping lanes and hazards. Buoys functioned as daymarks, but they could also be equipped with bells, whistles, and compressed gas lamps. Periodically, buoys would be hauled out for maintenance and brought to the depot, where they would be unloaded from a lighthouse tender to the dock. In 1933, plans were drawn for a new, larger depot (below).

35

The Galveston depot, shown here after construction was completed in June 1934, provided space for the repair and maintenance of boats and buoys, as well as storage for supplies. In the foreground, timber posts sit ready to be driven into shallow bay and Gulf waters and topped with beacons or channel markers.

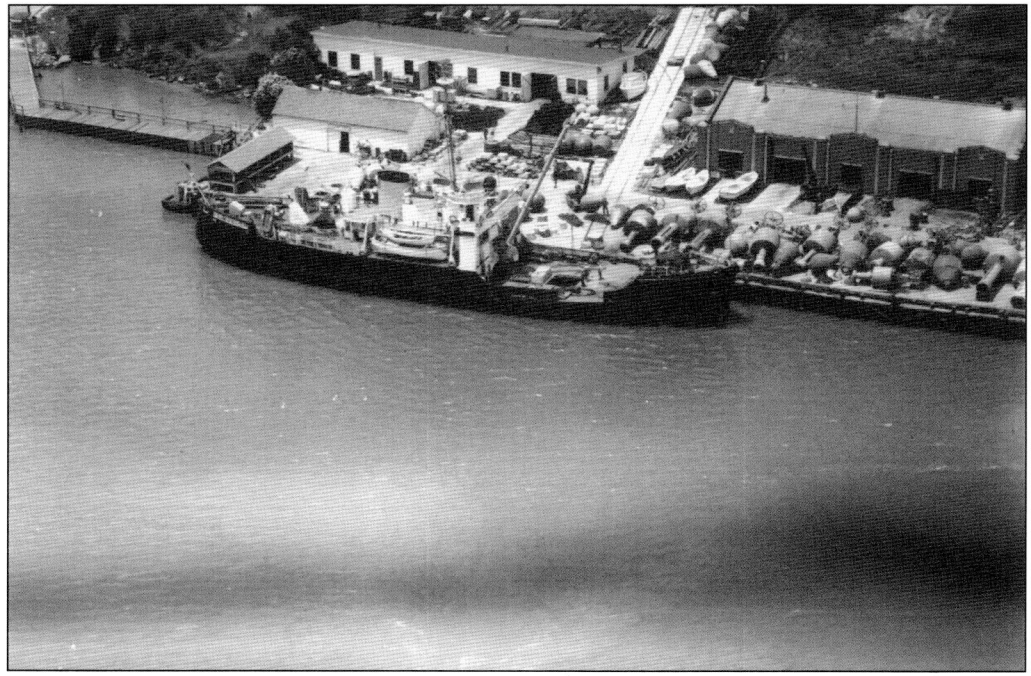
This photograph of the Galveston Lighthouse Service depot shows a lighthouse tender at dock, with buoys positioned on the dock. Each tender was equipped with a derrick boom that was used to transfer the 11- or 12-ton buoys from the dock to the deck, then into the water at the buoy's desired position.

Two
THE LIFE-SAVING SERVICE

Between 1878 and 1888, the US Lighthouse Service worked in parallel with the US Life-Saving Service to establish life-saving stations near busy ports along the Texas coast. This station at Velasco (on Follett's Island) was located near what is now Surfside Beach. Surfside was a popular resort area in the late 1800s; these visitors may have been vacationing nearby. (Courtesy of the Brazoria County Historical Museum.)

This map shows the locations of life-saving stations along the Texas coast. Although life-saving stations were often near lighthouses, the Life-Saving Service was a separate agency until 1939, when the US Coast Guard (which was formed through the merger of the Life-Saving Service and the Revenue Cutter Service, in 1915) merged with the US Lighthouse Board. (Map created by the author.)

Sumner Kimball helped to organize the network of mostly volunteer lifeboat stations into the professional US Life-Saving Service. Established in 1878, the US Life-Saving Service was a highly organized agency that trained experienced surfmen to respond to shipwrecks and other maritime emergencies. Kimball led the agency from 1878 until 1915, when it became part of the newly formed US Coast Guard, and oversaw its expansion beyond the East Coast.

Members of the US Life-Saving Service were usually experienced boatmen with extensive knowledge of the local area. One of their duties was to walk along the beach to keep watch for stranded ships, sometimes covering several miles in each direction. The service also kept watch in the lookout tower at the station, where the crew was prohibited from sitting down in order to prevent them from falling asleep. Lanterns carried along the beach not only lit the way for the crew, but could also be seen (from a short distance) by mariners. The sketch at right, by M.J. Burns, appeared in *Harper's Weekly*.

Most life-saving stations were two-story buildings with a lookout tower at the peak of the roof, like the Velasco station shown here. The first floor contained the boat room, equipment storage, and a common space for the crew. Upstairs, rooms contained cots for the crew, the station library and medicine chest, and a signal room. (Courtesy of the Brazoria County Historical Museum.)

This may be the first crew at the Velasco Life-Saving Station. Hired in 1888, they included keeper Joseph Simmons and six surfmen: William Hudgins, Alexander Follett, Henry Shannon, William Turk, John Ames, and William Jackson. (Courtesy of the Brazoria County Historical Museum.)

Surfmen of the Life-Saving Service had two ways to reach shipwrecked passengers. The first approach was to launch a Monomoy surfboat off the beach and row out to the stranded vessel. The Monomoy surfboat at Velasco was a 23-foot wooden craft made for a crew of six and designed to withstand rough seas. (Courtesy of the Brazoria County Historical Museum.)

The cork life vests worn by the crew in the photograph above can be seen more clearly in this illustration. Originally developed in Norway, this cork vest was invented by British naval officer and Arctic explorer John Ross Ward in 1854. These heavy, bulky vests consisted of blocks of cork wired to a canvas belt; they were the first life jackets.

CORK LIFE-BELT.

If the seas were too rough for the surfboat, the crew could retrieve people from a shipwreck with this beach rescue equipment. Pictured here are, from left to right, a Lyle gun, an equipment cart, a buoy bridge (two diagonal poles tied together at the top), and the tall pole with cross beam that served as the "ship" during training exercises. (Courtesy of the Brazoria County Historical Museum.)

Here, the Life-Saving Service crew at Point Isabel practices on the beach. They are wearing the summer "working suit" uniforms that were instituted in 1899. Every morning at breakfast, the keeper would inform the crew which uniforms they were to wear that day. (Courtesy of DeGolyer Library, Southern Methodist University, Dallas, Texas, Eric Steinfeldt Collection of Maritime Views, Ag2009.0005.)

The Lyle gun shot a line out over the ship, along with instructions for how to secure it. The sailors would then use the hawser to return the lazy (loose) end of the line to shore, where it would be suspended over the buoy bridge. The life-saving crew could then bring passengers back to shore, one at a time, in the breeches buoy (a sling-type seat).

The Lyle gun (right foreground) was not very big, but it could shoot a line to a ship almost 700 yards away. To keep the line from tangling, it was carefully coiled inside a faking box (left) so that it would play out smoothly. The design of both the shotline and the Lyle gun had been carefully developed, at Superintendent Sumner Kimball's request, through a series of experiments in 1878.

The equipment for the Lyle gun and breeches buoy rescue had to be portable so that the lifesaving crew could move it anywhere along the beach. A large two-wheeled cart, pulled by the crew, could carry the Lyle gun, faking box, blocks and pulleys, buoy bridge, hawser, breeches buoy, and whatever else was needed.

The use of rescue gear required regular practice, as the correct direction and angle of the shot were critical to reach a stranded ship. Crews drilled with beach equipment (pictured) on Mondays and Thursdays. Monday also included boat inspections, prior to Tuesday boat exercises. The crew practiced with signal flags on Wednesday and resuscitation on Friday. Saturdays were spent cleaning the station. (Courtesy of the Brazoria County Historical Museum.)

The breeches buoy was essentially a life preserver with a pants-like harness in which one person at a time could be transported along a rope from the ship to the shore. While this "passenger" looks calm, in a real situation, this would have taken place above rough seas, with one end of the rope attached to a ship that was almost certainly not stationary.

In order to move more than one person at a time from ship to shore, this "life car" was developed. It was a covered iron boat that could carry six or seven people at once. Although it was heavy and much more difficult to use, the life car made it possible to quickly move people off the ship when their numbers were great or time was of the essence.

Women frequently worked with the station crew to provide shipwreck survivors with beds, blankets, food, and clothing. The Women's National Relief Association was founded in 1880 to provide aid after people had been brought ashore, often with injuries or illnesses sustained during long hours of exposure or during the rescue operation itself. The all-volunteer organization was known as the Blue Anchor Society for its insignia—a blue anchor inside a circle of blue cable. Lucretia Garfield, the former First Lady, was one of its founders and served as its president. The WNRA collected and distributed donations to hundreds of life-saving stations along America's coasts so that surfmen did not have to give up their own meager allotments of food, clothing, and beds or be reduced to begging for help from the public. (Courtesy of the Brazoria County Historical Museum.)

This station near Port O'Connor was known as Saluria when it was established in 1880. The keeper (center) is probably Andrew Rasmussen, whose life was saved by this station when the ship he captained ran aground in 1885. He served as keeper from 1888 until he retired in 1918. Station Saluria closed in 1929. (Courtesy of the Victoria Regional History Center, Victoria College/University of Houston-Victoria Library.)

Most life-saving stations were built using standardized designs. The L-shaped 1880 Texas Design (pictured at Velasco) was developed by the architect J. Lake Parkinson, who had also created the 1876 Standardized Design stations built in Virginia and Maryland and the 1879 Michigan Design. The same design was used at San Luis Pass on Galveston Island (1879), Aransas Pass (1883), and Saluria (1880). (Courtesy of the Brazoria County Historical Museum.)

The Sabine Pass life-saving station, built in 1904, used the 1903 Gulf Design by architect Victor Mindeleff. Elevated on pilings to withstand storm surges and flooding, the station building housed the crew and its functions, while boats and equipment could be stored in the open space underneath. The crew slept on the second floor. (Courtesy of the author.)

As original stations were destroyed by hurricanes, they were replaced with new buildings. The 1903 Gulf Design was also used at Brazos Santiago (pictured, built in 1923), San Luis (1916), Velasco/Freeport (1917), and Aransas (1920). When it was built, the Brazos Santiago Life Boat Station was described by USCG personnel as "the finest Coast Guard Station in the world, if rigid inspection and first quality of materials and workmanship count for anything."

Three

SCREWPILES, A LIGHTSHIP, AND A CAISSON

At the turn of the 20th century, the heyday of lighthouse construction was ending in the United States. In 1895, Texas boasted five tower lighthouses—Bolivar Point, Matagorda Island, Sabine Pass, Aransas Pass, and Port Isabel; and six remaining screwpile lighthouses—Fort Point, Redfish Bar, Redfish Bar Cut, Halfmoon Reef, Halfmoon Shoal, and Brazos Santiago. Over the next 20 years, four distinctly different lights would be constructed, each unique on the Texas coast. (Map created by the author.)

The iron skeleton tower near Freeport was the first of these new lighthouse designs to be built. It was constructed near the mouth of Brazos River, just across the present-day Intracoastal Waterway from Surfside Beach and the old Velasco townsite. Freeport was a "company town" founded in 1912 by the Freeport Sulphur Company. In 1894, an advance in sulphur extraction technology called the Frasch Process was invented in Louisiana, which allowed the removal of the mineral from underground deposits. Engineers for the Freeport Sulphur Company had discovered the world's largest sulphur salt dome at nearby Bryan Mound in the early 1900s, and the Gulf Coast quickly became the largest sulphur producer in the world. The original Freeport sulphur mine closed in 1935, but since the 1970s, it has been used as one of the United States' two main petroleum reserve storage sites. (Map created by the author.)

The first ships to carry sulphur were schooners like the *Florence Howard*, pictured here taking on sulphur (also known as brimstone) at the Freeport docks in 1916. The *Florence Howard* was built in Stonington, Connecticut, in 1909; she measured 193 feet in length. (Courtesy of the Brazoria County Historical Museum.)

It was not long until more shipping capacity was needed to move all of the sulphur being produced from the world's largest sulphur mine. Soon, the docks at Freeport were crowded with large seagoing freighters, including several owned by the Freeport Sulphur Company. (Courtesy of the Brazoria County Historical Museum.)

The US Lighthouse Service had its own ships, including this lighthouse tender equipped with a large derrick boom (off the front mast), for moving buoys on and off the deck. This, one of the larger oceangoing tenders, is 180 feet long and powered by three steam engines. (Courtesy of the Brazoria County Historical Museum.)

The skeleton-tower design was developed by I.W.P. Lewis, a civil engineer and the nephew of early lighthouse builder Winslow Lewis. The skeleton tower featured an enclosed spiral staircase within a central column, held in place by iron struts and anchored into the ground with screwpiles. The tower's open structure was designed to withstand high winds. (Courtesy of the Brazoria County Historical Museum.)

Heald Bank and Sabine Bank are the remains of two barrier islands that lay along the Texas coast thousands of years ago. The ancient Texas shoreline extended much farther into the Gulf than it does today. Galveston Bay was created when the old Trinity River valley flooded; Lake Sabine was similarly created in the old Sabine River valley. During the same period, sea levels quickly rose, and the coastline moved inland between 15 and 60 feet per year. Sabine Bank was much larger than Heald Bank, and behind Sabine Bank's protective barrier, the upper Texas coast eroded more slowly than the section below Bolivar. Over time, these two barrier islands (now sandbanks) were covered by water. They now lie about 20 to 30 feet below the surface. In the early 1900s, Sabine Bank was about five miles wide and 30 miles long; Heald Bank was six miles long. (Map created by the author.)

Light Vessel 81 marked Heald Bank, which lies 34 miles southeast of Bolivar Peninsula and about 30 feet below the surface of the Gulf. In the early 1900s, the bank was located on the heavy freight line between Galveston and the Tortugas. LV-81 was built in 1904 or 1905 to help deep-hulled ships avoid running aground on Heald Bank, although vessels of all sizes were advised to avoid the bank when seas were rough. LV-81 was a fast, steel-hulled ship with a crew of 12. Like other lightships of its time, its hull was painted red with its name in white. It was equipped with lamps on each mast, a steam whistle, and a fog bell. Although it had a steam-powered propeller, it was also rigged to sail. It was moored off the southwestern end of Heald Bank, and its lights could be seen for 11 miles. LV-81 served mariners until it was replaced by a buoy in 1937.

The Sabine Bank lighthouse is a caisson-type lighthouse. It is the only one of this type south of Chesapeake Bay, and—at 15 miles offshore—the most exposed. The rest of the caisson lighthouses were located in bays and harbors along the upper East Coast or in the Great Lakes off the Michigan coast. They were primarily used in places where a heavy structure was needed to withstand the movement of ice and, in several cases, replaced screwpile lighthouses that had been destroyed by sea ice. These lighthouses consisted of a tower built atop a caisson—a watertight cylinder into which compressed air could be pumped, allowing men to work inside during the construction process. This technology was developed by engineers to construct the foundations of railroad bridges, including New York's Brooklyn Bridge. While many workers on that project suffered from decompression sickness (also known as caisson disease or "the bends"), the men at Sabine Bank apparently avoided it.

Congress authorized the Sabine Bank lighthouse in 1899 but did not appropriate the funds for it until 1900. These plans were prepared in 1901. The caisson was to be built with a false bottom. This drawing shows how workers would access the space beneath the caisson through an air lock, climb down a ladder, and dig out sand, which would then be pumped to the surface, allowing the metal caisson to sink farther into the sea bottom. The workers left space at the top to store tools, water cisterns, and other provisions. The caisson's final depth would be 38 feet below the surface of the water. Once it had reached its final depth, most of the cylinder would be filled with concrete to keep it in place. The rest of the lighthouse could then be constructed. Note the angled "cutting edge" at the outside bottom of the caisson near the figures of workmen.

The iron plates used to construct the lighthouse were manufactured by the Russel Wheel and Foundry Company in Detroit, then shipped to a shipyard in Sabine, Texas. The government sought bids for building the structure, but the lowest bidder's offer was rejected even though it would have been within the project's budget. When the contract was advertised a second time, no other companies bid on it. The US Lighthouse Service had to hire local workers for the lighthouse's assembly both in the shipyard and at sea. The first order of business was the assembly of the caisson. The cylinder was 32 feet in diameter and was comprised of five courses (rows) of iron plates. Workers assembled the first three courses, then caulked the structure using pitch (resin) and putty to make it watertight. It was then ready for its maiden voyage into the Gulf.

The "cutting edge" at the bottom of the cylinder consisted of outside and inside walls with an angled lower surface to help it cut into the sea floor. The space within the cutting edge was filled with two feet of concrete (for stability) before the caisson was launched into the water. Here, the caisson is ready to launch on March 25, 1904. Note the men standing on the ways.

The caisson was built on the shipyard's ways, a structural system used to support a vessel during construction. In this photograph, the caisson has just been launched from the sliding ways—the wooden timbers angled down into the water. Because the caisson had a flat bottom instead of a keel, it could be built on a flat platform and then pushed into the water with hydraulic jacks.

Once the caisson was in the water and secured to the wharf, its draft (the distance between the waterline and the bottom of the vessel) was three and a half feet. A fourth course of iron plates was added to the top of the caisson and two feet of concrete poured over the floor inside. The additional weight caused the caisson's draft to increase to 12 feet.

The final step in the construction of the caisson was the addition of a fifth course of iron plates, as well as the top cover, airshaft, and wooden cofferdam (airtight enclosure). This photograph shows workers inside the caisson on April 19, 1904, probably preparing to add the last row of iron plates.

With everything in place and the cylinder watertight, the caisson was towed out to its final destination over Sabine Bank on June 23, 1904. Over the bank, workers had constructed a system of wooden falsework in advance of the caisson's arrival. The falsework provided a work platform as well as a way to ensure that the caisson stayed in place during the rest of the construction process. Initially, the workers had no real protection from the elements. However, several buildings were erected after a hurricane washed over the platform and forced the men to seek shelter inside the open top of the caisson.

Barges like the *Calcasieu* (pictured) were used to move men and supplies to the construction site and return workers to the shore. Around the turn of the century, such barges were typically employed to transport lumber and cotton from East Texas and sulphur from a mine near Lake Charles, Louisiana. The importance of the ports around Sabine Bank—Port Arthur and Beaumont on the Texas side, and West Cameron, West Calcasieu, and Lake Charles on the Louisiana side—made the Sabine Bank lighthouse critical. This importance only increased after the discovery of oil at Spindletop in Texas, which caused a significant uptick in ship traffic in the area, and, consequently, ships running aground on the bank. The construction of the lighthouse could not have been more timely, since oil and chemical production was fueling the rapid growth of the Texas and Louisiana economies.

In addition to shelters for the workers, as seen at left in the image above, the platform held steam pumps (the three vertical cylinders with vent pipes) and one steam engine (with the tallest pipe). The pumps were used to remove water and sand from the caisson and to pump in compressed air. The pumps were almost certainly powered by coal and were specifically designed to use saltwater. An early 1900s advertisement for mining equipment, which used such pumps for similar purposes, offers a better view of this type of steam pump. (Below, courtesy of Mitchell, Lewis & Staver Company.)

With the falsework wharf, construction materials, and caisson finally in place, the workers dug out the sand beneath the cylinder, allowing it to sink into the bottom. When it had finally reached the desired depth, the caisson was filled with concrete to hold it in place. A small storage room was left empty inside to store tools and water. The work was completed in August 1904, just as the project ran out of money. Another $12,000 was appropriated in March 1905, barely before a hurricane destroyed the original wooden work platform. Work resumed in July 1905 and was nearly completed when this photograph was taken in March 1906. The caisson and tower were painted red to function as a daymark, and the lantern room and roof were painted black. It exhibited a third order lens and had a foghorn. Note the open gallery (porch-like area) around the top of the caisson.

In May 1906, only a few months after it had been completed, the Sabine Bank lighthouse received a visit from one of the large steam-powered lighthouse tenders that were used to move buoys and deliver supplies. In this photograph, the foghorn is visible projecting from the gallery on the left side of the lighthouse.

The Sabine Bank lighthouse's own tender, used by the crew, is shown here. The lighthouse crew had several boats they could use to get to and from shore. When not in use, the boats were hauled up to the gallery platform by winches and suspended from davits (cranes that arch up and over the side of the lighthouse) on winch cables.

The last lighthouse built in Texas was in Galveston. Until the Houston Ship Channel was dredged through Galveston Bay from 1912 to 1914, enabling Houston to develop its own deepwater port, cargo had to be transferred at Galveston from freighters to "lighters" for the remainder of the trip to Houston. Freighters still had to reach the Galveston harbor, however, and two long rock jetties were constructed to keep that channel clear of sediment flowing down the coast. Work started in 1874; by the early 1900s, the jetties stretched five miles into the Gulf. The North Jetty connected to the land at Bolivar Peninsula and the South Jetty at Fort Point. The first request for a lighthouse to mark the jetties was made in 1876, although the US Congress did not authorize funds for its construction for another 20 years. An early lighthouse built at the end of the North Jetty in 1897 was a small wooden building with a single room maintained by the keepers from Bolivar; it was destroyed during the 1900 hurricane.

A new lighthouse was built toward the end of the South Jetty starting in 1904 or 1905. The 1896 appropriation had called for a screwpile lighthouse similar in design to the one at Rebecca Shoal (pictured above) in the Florida Keys. That lighthouse, built in 1886, consisted of an iron platform topped by a square, Chesapeake-style wooden building. However, after a 1909 hurricane damaged the Galveston Jetty Light's iron pilings during construction, the builders began to consider alternate plans. By 1913, it had been decided that the tower would be a five-story cylindrical structure made of steel and reinforced concrete. (Above, courtesy of the State Archives of Florida; below, map created by the author.)

A wharf of heavy timbers was built in 1905 as a work platform. Workers drove nine iron piles, five of which are shown here, down through the rock jetty, and placed 200 tons of sandstone and granite riprap around the piles as protection. The rest of the structure was built over these pilings, much like how a house is built one story at a time. Lighter steel columns were placed over the piles; the entire structure was held together with steel struts and tie rods. The construction wharf was destroyed twice, during hurricanes in 1915 and 1916, and had to be rebuilt both times. Some of the struts were bent during the 1916 storm.

In 1917, workers poured a concrete base (49 feet square and 10 to 15 feet deep) around the pilings and added more riprap around it, as shown here.

After the base was built, workers needed more money to build the tower. No fewer than four hurricanes had delayed the project by damaging the substructure and superstructure and washing away materials and equipment. Even part of the lens was lost during a storm while in storage at Mobile, Alabama, and had to be replaced. This image shows the lighthouse in November 1917, when work was still in progress. The exterior walls of the tower were made of concrete and reinforced with an expanded steel mesh. On the outside, the walls were covered with two coats of plaster stucco. The first coat used cow hair to strengthen the stucco; the second coat included a waterproofing agent. The two davits visible in this photograph were undoubtedly used to haul up construction materials and supplies. The Galveston South Jetty lighthouse finally became operational 14 years after construction began; its third order lens exhibited light for the first time on November 12, 1918.

With the lighthouse finished, work could begin on a fog signal tower, which was built between December 1921 and June 1922. The concrete base shown here was placed around the base of the fog signal tower in June 1925. No construction delays occurred due to weather—only two minor hurricanes made landfall on the Texas coast between 1921 and 1925, and neither of them landed at Galveston.

A new lower boat landing and winch lift (shown at left in front of the structure) and upper boat landing were built in 1934, making it easier for the crew to move supplies (and themselves) on and off the lighthouse platform. The construction of the Galveston Jetty lighthouse, which had been ongoing for 30 years, was now officially complete.

In the image at left, a crew member looks down from the lower boat landing in 1939. In the image below, "K.P., Joe, and Wakefield headed off for a wild weekend" of shore leave. In 1940, head keeper Earl K. Wakefield, first assistant Englisbee K. Peyton, second assistant Howard G. Bardwell, and third assistant John F. Ganaway were stationed at the lighthouse. By the mid-1930s, the US Lighthouse Service was coming to an end. In 1939, the Lighthouse Service merged into the US Coast Guard. Many of the civilian lighthouse keepers stayed on with the Coast Guard, receiving commissions commensurate with their experience, while others retired rather than work with the often much younger Coast Guard crewmen.

Four

WARS, HURRICANES, AND DESTRUCTION

The Texas coast is a dangerous place, and not just for ships like the steamship *Nicaragua*, which sank in 1912 at "Devil's Elbow" off the shore of Padre Island during a terrible storm at sea. Only part of the hull was left when this photograph was taken in 1936, but the remains are still visible today. (Courtesy of Corpus Christi Public Libraries.)

THE UNION BLOCKADE and LIGHTHOUSES DAMAGED or DESTROYED DURING THE CIVIL WAR

During the Civil War, Texas was blockaded by the Union Navy, and both Union and Confederate forces tried to prevent lighthouses from being used by the other side. Although blockades were in place all along the Atlantic and Gulf Coasts, this was particularly important in Texas because most of its trade still arrived via water. The great era of railroad building in Texas had commenced before the war began, but rail trade was still somewhat limited. By cutting off shipping along the Texas coast, the Union could prevent the Confederacy from trading its goods for weapons. In addition, if the Union Army was to invade Texas, it would have to do so by sea. With few passable roads or bridges over the many bayous and rivers along the coast, an invasion from the east would have been nearly impossible. (Map created by the author.)

The Battle of Corpus Christi, also called "the Vicksburg of Texas," was a victory for a force of about 700 Texans under the command of Maj. Alfred Hobby. Although the five Union ships led by acting Lt. John Kittredge were well armed, his 100 men were unable to take Corpus Christi and Pass Cavallo. (Courtesy of Corpus Christi Public Libraries.)

This 1862 newspaper article from the *New York Herald* demonstrates the importance of the lighthouse at Aransas Pass, which is featured prominently in the middle of the map. Lighthouses provided excellent observation towers, and their lights could be used by both the blockade ships and blockade runners. As a result, all of the lighthouse lanterns along the Texas coast were extinguished during the Civil War.

Pictured in this image from the October 10, 1863, issue of *Harper's Weekly*, the Sabine Pass lighthouse was the focus of several skirmishes that resulted in injuries and deaths on both sides. For several weeks, small parties of Union and Confederate troops had each been using the lighthouse tower to spy on each other. In April 1863, several Union sailors on a scouting mission were in the lighthouse tower when they saw a small boat heading toward them. They hid and ambushed the Confederate troops as they came ashore. The Confederates turned the tables a week later when the Yankees returned to the lighthouse. About 30 men were waiting behind the lighthouse keeper's cottage, and when the shore party approached, the Confederates surprised them and chased them back to their boats, firing the entire way. Nearly all of the Union troops were killed or critically injured, and the Confederates held the lighthouse from that point forward.

The loss of the Sabine Pass lighthouse as an observation post was important because it prevented the Union from seeing the defenses being prepared at Sabine Pass. Initially, the pass was protected by a low "mud fort" close to the mouth of the river, which was within easy reach of Union gunboats. By the time four Union gunboats attacked several months later, a new fort (Fort Griffin) had been constructed upriver. During the battle, Lt. Richard "Dick" Dowling led a small contingent of 45 young Irishmen in a successful defense of Fort Griffin against a barrage from the Union gunboats. Had the Union won the battle, 4,000 troops were poised to invade Texas. Although the pass had been considered unworthy of defense for several years, the battle waged there in 1863 was called "the Thermopylae of the South" by none other than Confederate president Jefferson Davis. This monument to Lt. Dick Dowling and his men was erected in 1936 at the Sabine Pass Battleground Historic Site in Jefferson County, Texas. (Courtesy of Port Arthur Public Library.)

75

Proclamation!

THE call for Slaves to work on Fortifications and other defensive works is hereby reduced to one-fourth of the male force in the counties specified in my proclamation of the 4th inst.

A reduction to this basis will be immediately made by discharging a portion of those already reported.

Slaveholders who have not responded, are required to forward at once their pro rata, otherwise they will be dealt with strictly according to military law.

J. BANKHEAD MAGRUDER,
Major General Commanding,
Ju27tw6t Dist. of Texas, New Mexico & Arizona.

Proclamation!

WHEREAS, the port of Sabine Pass, on coast of Texas, has ceased to be actually blockaded by the capture of the enemy's fleet near the same, I hereby issue this Proclamation, inviting friendly neutral nations to resume commercial intercourse with this port until an actual blockade has been re-established with the usual notice demanded by the law of nations.

J. BANKHEAD MAGRUDER,
Major Gen'l Commanding Dist. Texas,
Official: New Mexico and Arizona.
Geo. A. Magruder, Aid-de-Camp. ju26tf

The fort defended by Dick Dowling and his band of Irishmen was designed by two Confederate engineers, Julius Kellersberg and Valery Sulakowski, and built by 500 enslaved men who had been conscripted by the Confederate army for that purpose. This newspaper clipping documents the requirement for slaveholders to contribute free labor to the Confederate cause. (Courtesy of Woodson Research Center, Rice University.)

The proclamations on the previous page were made by John Bankhead Magruder (pictured), who led the Confederate forces in Texas, New Mexico, and Arizona. Magruder ordered the destruction of several Texas lighthouses in 1862, although not all of the attempts to carry out his orders were successful. (Courtesy of Corpus Christi Public Libraries.)

BOMBARDED BY MISTAKE.
Lighthouse on Bolivar Peninsula, Texas, Shelled in Practice.

GALVESTON, TEXAS, Nov. 16 — Through some miscalculation, Boliver Peninsula, in the vicinity of the lighthouse, was subjected to bombardment by three-inch guns in target practice at Fort San Jacinto for about two hours yesterday.

One three-inch empty projectile tore a hole through the ninety-foot tower of Bolivar lighthouse about twenty-five feet from the base.

Another shell struck a few feet from the front yard gate of a family living near the lighthouse. No one was injured. It was estimated that about twenty-five projectiles struck land, the rest striking the water, where they apparently were intended to fall.

The Civil War did not pose the only military threat to Texas lighthouses. In 1917, during World War I, gunners from Fort San Jacinto accidentally shelled the Bolivar lighthouse; apparently the gunners needed quite a bit more practice. The Army maintained three coastal defense stations on both sides of the channel between Bolivar Peninsula and Galveston Island. Fort Travis was on the Bolivar side; Fort San Jacinto and Fort Crockett were on the Galveston side. Fort San Jacinto had several gun batteries shooting mortars and guns of various sizes. Battery Croghan was the only battery with three-inch guns. Battery Croghan had been built in 1900 but was wrecked in the hurricane. It was not rebuilt and rearmed until 1911. The remains of the gun battery are still accessible and are located near the former site of Fort Point lighthouse. (*New York Times* text reproduced by the author.)

TRACKS of MAJOR HURRICANES during the EARLY LIGHTHOUSE ERA

Military action was not the only destructive threat to Texas lighthouses. Each year, from June through October, hurricanes rumble out of the Gulf of Mexico and toward the Texas coast. August and September are the most dangerous months, when the surface temperature of the ocean is highest, and that heat fuels a storm's power. When a hurricane makes landfall, the coastal communities in its path see the most damage. In the 152 years between 1818 and 1970, nearly 100 hurricanes and tropical storms struck Texas. Lighthouses and life-saving stations have been places of refuge during hurricanes, but their keepers and crew have risked (and given) their lives to keep the lights burning and protect both boats at sea and people in their care. As this map shows, no part of the Texas coast has been spared. The town of Indianola was completely decimated by a hurricane, as was Saluria. The 1900 hurricane that largely destroyed Galveston remains the most deadly natural disaster in US history. (Map created by the author.)

79

This photograph of Galveston was taken after the 1867 hurricane. Galveston's major commercial street, The Strand, is flooded and full of debris, including several boats. A note on the photograph reads "on right, houses floated away." (Courtesy of DeGolyer Library, Southern Methodist University, Dallas, Texas, Lawrence T. Jones III Texas Photography Collection, Ag2008.0005.)

Velasco, at the mouth of the Brazos River, was a bustling port town as well as a summer resort for wealthy families who lived on nearby plantations. After the 1875 hurricane destroyed most of the town, it was moved farther upstream. This likely shows the new townsite, which was established in 1891. Nine years later, the 1900 hurricane destroyed that, too. (Courtesy of the Brazoria County Historical Museum.)

Repeated battering by storm after storm is just a way of life on the Texas coast. Three-quarters of Indianola was wiped out by the 1875 hurricane, and nearly 200 people died. This photograph shows the aftermath of the 1886 storm that finished off Indianola for good. (Courtesy of the Victoria Regional History Center, Victoria College/University of Houston-Victoria Library.)

Lighthouses were not immune to these storms. The wharf and boathouse (pictured) at the Matagorda Island lighthouse, which were built around 1900, washed away during one of the many destructive hurricanes that pounded the Texas coast in the early 1900s. About a mile away, the walkway to the lighthouse was completely flooded.

The 1900 hurricane that struck Galveston laid waste to most of the island. Houses were torn from their foundations and floated away or were destroyed, leaving behind huge piles of debris. Between 6,000 and 8,000 people died, mostly from drowning. Lighthouse keeper Harry Claiborne was credited with saving 125 people who took shelter from the storm on the stairs inside the Bolivar Point lighthouse for two long days and nights. After the storm, he used all of his provisions to feed them. Claiborne served at Bolivar for 24 years—until 1918. The storm remains the most deadly natural disaster in the history of the United States. (Courtesy of the Galveston Historical Foundation Preservation Resource Center.)

Survivors of the 1900 storm included this child and a little dog, who (according to the caption printed on this stereograph) was pulled from the wreckage in Galveston after more than a month. (Courtesy of DeGolyer Library, Southern Methodist University, Dallas, Texas, Lawrence T. Jones III Texas Photography Collection, Ag2008.0005.)

Charles Bowen, the keeper at Halfmoon Shoal lighthouse in Galveston Bay, was not as lucky. The storm drove many large ships into the bay and onto shore. Several ships smashed into the freighter *Kendall Castle*, propelling it toward—and ultimately over—the lighthouse. Bowen's body was never recovered. His father, wife, and daughter—all of whom lived in Galveston—also perished in the storm. (Courtesy of Galveston Historical Foundation Preservation Resource Center.)

In many cases, hurricanes knocked down houses and businesses, leaving communities to face years of rebuilding only to be struck by another storm just as they were getting back to some sense of normality. This photograph captures the storm damage to Aransas Pass in 1919, following a string of hurricanes in 1900, 1905, 1909, 1914, 1915, and 1916. (Courtesy of Corpus Christi Public Libraries.)

Between 1914 and 1919, August hurricanes repeatedly damaged the lighthouse keeper's dwellings at Aransas Pass. This 1914 photograph shows the repairs needed when doors and windows were blown out. The keeper's house on the left was eventually destroyed in the 1916 hurricane and replaced. Keeper Thomas Roberts was commended for keeping the lighthouse lit during the 1916 storm and for helping with relief efforts.

This keeper's house was built after the 1916 storm. It is made of hollow clay tile covered by stucco, in order to stand up to extreme weather. The house was barely completed when the 1919 hurricane washed away the old assistant keeper's cottage. The remains of that dwelling's cistern and supports can be seen in this photograph taken while the hurricane flood waters were still high.

The August 1915 hurricane was said to be as large and destructive as the 1900 storm. By then, Galveston was protected by a seawall and sustained much less damage; fewer lives were lost than in the earlier disaster. The structure for the Galveston Jetty lighthouse, then under construction, was bent during the 1915 hurricane, which also washed away the construction wharf and materials. It was similarly damaged in August 1916.

Just down the coast, the relatively new (1896) lighthouse and keeper's dwellings at the mouth of the Brazos River, near Freeport, survived relatively intact, as shown in the above photograph taken from the bayou on the north side of the peninsula where the lighthouse was located. The damage was mostly confined to the southern/Gulf side of the site and included damage to the boathouse (below) and a destroyed T-wharf and walkway between the station and the wharf. An oil tank was also destroyed, spilling oil on the ground.

Not long after it was built in 1900, the lighthouse at Redfish Bar Cut (above) was barely missed (unlike the Halfmoon Shoal lighthouse) by a huge freighter set adrift by the hurricane that destroyed much of Galveston. This 1914 photograph shows the lower platform and cisterns, which were swept away by the deadly 1915 hurricane. The old Redfish Bar lighthouse, visible in the background along the horizon, was also lost during the 1915 storm. During the time that elapsed between these two hurricanes, Galveston had constructed a seawall for protection along the Gulf side of the island. The 1915 storm was nearly as large and strong as its predecessor, and while it was still incredibly destructive (below), the damage was not as widespread.

The August 1915 hurricane also seriously damaged the Sabine Bank lighthouse off the coast near the Texas/Louisiana border. This photograph shows the loss of the gallery, railings, and roof, as well as the davits and the station boat.

By 1917, the Sabine Bank lighthouse had been cleaned up and repaired. The repairs included the replacement of several iron plates that had been torn away from the gallery floor as well as on the main tower above the gallery roof. The keeper at the time was Albert Modawell. The lighthouse was severely damaged again during a hurricane in September 1919.

The Sabine Bank lighthouse's exposed location left it at considerable risk for storm damage. During hurricanes, waves routinely reached the gallery level or higher—as high as 35 feet above sea level (well above the roof of the gallery). Because the lighthouse was difficult—if not impossible—to access without a boat lift, the davits and winches were essential equipment. On at least one occasion, the lighthouse keepers were left stranded after a storm destroyed their boats and they were unable to get to shore. The keepers from Sabine Pass provided assistance to the Sabine Bank station's crew on several such occasions. After the 1919 hurricane, the gallery was enclosed and the boat davits moved to a higher position in order to better shelter the lighthouse keepers and protect their tenders. In this 1942 image, the Sabine Bank lighthouse is shown from a different angle.

During the 1914 storm, the Brazos and Colorado Rivers flooded for 40 miles inland. The keeper of the Velasco life-saving station, John Steinhardt, took his crew and two boats 75 miles upriver by railroad, where they rescued 178 people who had been stranded in trees and on rooftops by the rising water. The next year, with the 1915 hurricane approaching, the Florea family, vacationing in nearby Surfside, "wanted to see a real storm" and refused to evacuate. As the hurricane intensified, they took shelter at the station, along with Steinhardt's wife, Minnie, and seven-year-old daughter, Anita, who had refused to leave without him. When the station building broke up, Anita was swept away by the sea. Minnie drowned in her husband's arms. The Florea family also perished, with the exception of one daughter, who took hold of two planks and spent 36 hours floating through the Gulf of Mexico before washing up 40 miles away at Galveston. (Courtesy of the Brazoria County Historical Museum.)

The strength of the 1915 storm was focused on the upper Texas coast; the hurricanes of 1916 and 1919 hammered the lower. This photograph of Port O'Connor, just inside Matagorda Bay, was probably taken in 1919 when the town was destroyed by a storm. (Courtesy of the Victoria Regional History Center, Victoria College/University of Houston-Victoria Library.)

Corpus Christi was hit by hurricanes twice—in 1916 and 1919. The earlier storm killed 20 people and caused more than $1.5 million in property damage. The second hurricane came ashore with tides 16 feet above normal levels and 110-mile-per-hour winds. It was far more destructive than the 1916 storm, killing 284 and inflicting more than $20 million of damage. (Courtesy of Corpus Christi Public Libraries.)

Also in 1919, the gallery and entire east side of the Halfmoon Reef lighthouse was torn off and the building opened to the elements. Keeper Archie E. Fox (possibly the person on the left side of this photograph) began his service here after the storm and kept the light working for the next two years while the station was being repaired.

Padre Island, located at the southern edge of the Texas coast, suffered most of its hurricane damage in the second half of the 20th century. Natural disasters were not responsible for the loss of the Brazos Santiago lighthouse, however. The old lighthouse (at left in the image) was destroyed by fire in 1940, not long after the new station (at right) was completed.

Five

AUTOMATION, ABANDONMENT, AND REBIRTH

Throughout the 20th century, advances in technology made it possible for the US Coast Guard to automate, and then discontinue altogether, the lighthouses that maritime traffic had relied on since the 1850s. One by one—and often under protest from local communities that still valued them—the lamps of Texas lighthouses were extinguished. Pictured here is the Sabine Pass lighthouse.

TEXAS LIGHTHOUSES in the mid-TWENTIETH CENTURY

By the middle of the 20th century, only the following Texas lighthouses were operational: Sabine Pass, Sabine Bank, Bolivar, Fort Point, Galveston Jetty, Brazos River, Matagorda Island, Aransas Pass, Brazos Santiago, and Port Isabel. The robustly built tower lighthouses, which had been repaired or rebuilt after the Civil War, all remained, having withstood dozens of hurricanes in the decades since the war. Fort Point and Brazos Santiago, the last two of the screwpile "bug" lighthouses to be constructed, were also the last two survivors of their kind. Over the next few decades, they would also be lost. Lighthouses, which are purpose-built to serve a very specific function, are hard to use for anything else. Although five towers still stand today (Sabine Pass, Bolivar Point, Matagorda Island, Aransas Pass, and Port Isabel), only two (Matagorda Island and Aransas Pass) remain active navigational aids. All are remembered, however, in communities along the coast that have preserved their lenses, lantern rooms, photographs, and history. (Map created by the author.)

In this c. 1950s image, a pair of Coast Guardsmen return to the Galveston South Jetty lighthouse. At that time, the three men assigned to the lighthouse worked 20 days on and 10 days off so that two were always on duty at the isolated station, located five miles out to sea. In later years, the crew was increased to four men working 18 days on and six days off. When they were not tending to equipment, they passed their days fishing, listening to the radio, reading, cooking, and cleaning. Mail and supplies were delivered every day, and those with families on the mainland were occasionally allowed to have visitors. The crewmen lived in the lighthouse tower until 1952, when the one-story living quarters (at right in the image) were built on a separate screwpile platform next to the lighthouse tower.

In 1962, only a few years before the Galveston Jetty lighthouse was unmanned, this photograph of it was taken by Coast Guard photographer R.F. Gliniecki. The Coast Guard had already noticed that both the platform structure and the tower were beginning to deteriorate, a result of constant exposure to the salty sea air and frequent storms in the Gulf of Mexico. Much of the damage could not be fixed easily, if at all—the iron piles on which the lighthouse stood were rotting, and the steel struts and tie rods holding the structure together were rusting. The cylindrical lighthouse tower was in similarly poor condition. The decision to abandon the lighthouse was made easier because, by that time, new automated equipment powered by electric lines, rather than generators, was available to replace all of the old apparatus that had required a person to operate.

The original fog signals were bells, which were first rung by hand and then using a clockwork mechanism (as shown at right). Bells could be large or small; the fog bell at the Brazos River lighthouse weighed 1,800 pounds. These were later replaced by whistles, horns, and other mechanically operated devices.

By the 1900s, the diaphone foghorn had come into standard use in lighthouses. The diaphone horn used pistons to force compressed air through a tube. The "F-2-T" diaphone horn was the model most often used in lighthouses. The letter designation indicates that it was the two-tone version of the "F"-size horn. The F-2-T produces the high-low foghorn sound that is still easily recognizable. The plan shown here is for the foghorn at the Galveston Jetty lighthouse.

97

This photograph of two diaphone horns was taken in August 1926 by R.M. Snarr, a "mechanician" at the Galveston Jetty Lighthouse. A lighthouse mechanician (or, in today's parlance, mechanic) was responsible for installing and maintaining all of the station equipment. Snarr was probably documenting his work for a report to his district inspector.

When the Galveston Jetty lighthouse was staffed, the foghorn had to be turned on by hand when a crew member determined that it was needed. When the station became unmanned in 1969, the fog signal was fully automated; a photoelectric cell would send out a beam of light that, if it reflected off of fog and back to a sensor, would trigger the horn.

Foghorns, whistles, and other sound beacons often were not loud enough to be heard at much of a distance. As a result, lighthouses began to use radio beacons. Each beacon sent out a distinctive radio signal that could be received by a ship's navigation systems and used to calculate distance and position. The radio beacon on the tower, pictured at right in a 1940 view from the Galveston Jetty lighthouse, was moved to the Coast Guard station on Galveston Island (below, pictured in August 1944) after the lighthouse was automated in 1969. The Galveston Jetty lighthouse was officially abandoned in 1973 due to its deteriorated condition. In May 2000, a storm destroyed the remains of the lighthouse.

The Galveston Jetty lighthouse was automated when commercial power lines were run to it in 1969; until that year, the keepers' main job had been to maintain these generators, which powered the lighthouse systems, and to make sure they always had an adequate supply of fuel on hand. With the electric power line came automation, and keepers no longer had to live at the lighthouse.

Once the lighthouses were electrified, only a relatively small, 1,000-watt light bulb was required to provide 10 times the candlepower of the old lamps (and throw the light a distance of 15 miles or more). This photograph shows the difference between the size of the light bulb and the size of a Fresnel lens. Bulbs like this one would be used for 2,000 hours (about two and a half months) before being changed.

During the second half of the 20th century, the large Fresnel lenses in lighthouses were replaced by rotating beacons. Rotating beacons still used Fresnel lenses—the beacon pictured at right has two—but on a much smaller scale. These are sometimes called aerobeacons and, in fact, the US Lighthouse Service became responsible for lights and radio beacons at airports starting in 1926. The Lighthouse Service Airways Division was established after lights used to guide airmail pilots caused confusion among ships' pilots, demonstrating the need for coordination. Since the Lighthouse Service already had a system for establishing and maintaining navigational aids at sea, it was asked to extend that to civil aviation. This lasted until 1933, when those responsibilities were transferred to another government agency. By then, the Lighthouse Service had realized that rotating beacons could be used in lighthouses.

FIGURE 6-1 Type DCB 10 Rotating Beacon

Most Fresnel lenses were removed from Texas lighthouses in the 1950s and 1960s; many are now exhibited in museums or government buildings. This lens from the Galveston Jetty lighthouse was originally exhibited in the Galveston County Museum in downtown Galveston. After Hurricane Ike damaged that building, the museum was forced to close. The lens is now on display in the lobby of the Galveston County Commissioners Court building, also in downtown Galveston. Other locations displaying Texas lighthouse lenses include the Museum of the Gulf Coast in Port Arthur (Sabine Bank lens), Calhoun County Museum in Port Lavaca (Matagorda Island lens), and the Smithsonian Institution National Museum of American History (Bolivar Point lens). Port Isabel still retains its lens, which—along with the rest of the lighthouse—was restored in the 1950s and is still functioning as an aid to navigation; the site is owned by the State of Texas and managed by the Museums of Port Isabel.

As pictured here, visitors to the Brazoria County Historical Museum in Angleton can view the lens from the Brazos River lighthouse, and the Freeport Historical Museum in downtown Freeport also maintains a lighthouse model and exhibit. The fate of pieces of old lighthouses can be controversial, as was the case in Port Aransas when the Coast Guard made plans in 1955 to ship the Aransas Pass lens to the Coast Guard museum in Connecticut. Outraged local citizens threatened to take the lens and "bury it in the mud," just as Confederate soldiers had done during the Civil War, in order to once again keep it out of Yankee hands. Some admitted that they would rather see it go to Corpus Christi than Connecticut. In the end, the lens remained in Port Aransas, where it is now displayed in the Port Aransas Museum. (Courtesy of Brazoria County Historical Museum.)

In Angleton, not only is the lighthouse lens on display in the Brazoria County Historical Museum, the lantern room that once topped the Brazos River lighthouse sits on the museum grounds. The lantern room was installed there in the 1960s, when the museum building was still the county courthouse. In this photograph, workers are preparing to install the finial on the lantern room's roof. (Courtesy of the Brazoria County Historical Museum.)

Now protected by a ring of shrubs, the Brazos River lighthouse lantern room is on the west side of the museum grounds, along Velasco Street. This is not the only lantern room on public display; the turret from the Galveston Jetty lighthouse is installed on the grounds of Galveston College, and the Sabine Bank lantern room is at Bert Karrer/Lions Community Park in Sabine Pass.

The Brazos River lighthouse was conveniently located near the area that would become the Port of Freeport (also known as Brazosport). During the 20th century, the port had dredged, dug, and rerouted many of the bayous, canals, and channels around the lighthouse reservation to improve shipping. Dow Chemical, which had established many processing plants in the area, was growing. In the 1960s, Dow officials made a deal with the Coast Guard. They needed to build ship docks at the mouth of the Brazos, and it was "near impossible" to do that without using the lighthouse site. The Coast Guard also had a problem to solve. In 1958, the Outer Bar Channel had been realigned, and this had caused coastal pilots to change the way they used existing range lights to navigate. The range lights were difficult to see at night, particularly against the backdrop of the nearby Dow Chemical plant, which was brightly lit.

To solve the problem, Dow Chemical proposed a land swap. They would provide a site and build a new range light tower, install the Coast Guard's backup generators, and provide electric power for the light. In return, they would receive the land on which the lighthouse stood, which could be turned into their new dock. The Coast Guard agreed to the deal, and a new light tower was built near the site of the old lighthouse. The Brazos River lighthouse was dismantled in 1967, and its buildings were removed. It had the distinction of being the last lighthouse built on Texas soil and had served the Brazos harbor for 71 years. This 1960 photograph shows the lighthouse reservation and nearby shipping canals. A model of the lighthouse is now part of a permanent exhibit in the Freeport Historical Museum.

These photographs of the Sabine Pass lighthouse were taken in the 1940s. The last light was extinguished at Sabine Pass in May 1952, despite a vigorous effort by keeper Steve Purgley and the local community to save it. As at Galveston, the radio beacon was moved to the nearby Coast Guard station. The tower remained in use as a daymark for two more years until the site was transferred to the State of Louisiana for use as a wildlife conservancy. (Although the lighthouse has historically been considered part of the Lone Star family, it is actually located across the border in the Pelican state.) The wharf, once the only access point for the lighthouse, is long gone.

Due to its remote location, it was difficult to maintain the Sabine Pass lighthouse or find a buyer or use for it. The State of Louisiana gave it back to the federal government, which tried to transfer it to nearby Lamar University as a teaching station, but that fell through. The keeper's houses burned to the ground during a grass fire in 1976. Vandals smashed windows and removed the copper roof, leaving only the cage that surrounded the lantern. Several businessmen bought the site in the 1980s, planning to turn it into a private club or bed-and-breakfast, neither of which materialized. Finally, in 2001, those individuals gave the 45-acre property to the Cameron Preservation Alliance–Sabine Pass, which was formed to save and restore the lighthouse. Several years later, a road was built to the lighthouse, making it accessible by land for the first time. The tower was damaged when Hurricane Rita made landfall at Sabine Pass in 2005 and again during Hurricane Ike in 2008. It was listed in the National Register of Historic Places in 1981.

The Sabine Bank lighthouse, pictured here in 2012, was automated after World War II. By the 1970s, its lens had been removed and donated to the Port Arthur Historical Society's Museum of the Gulf Coast. The new lamp was equipped with solar electric power. Getting to the top of the light for maintenance was difficult for Coast Guardsmen in small craft, so a proposal was made to remove the tower entirely and replace it with a smaller structure and light. A local effort was made to save the lighthouse either by restoring it in place or moving it ashore. When neither of those alternatives proved to be feasible, in 2002, the Coast Guard proceeded with dismantling the tower. The top section and lantern room were given to and refurbished by William Quick and R.L. Eldridge, who had led the initiative to save the lighthouse. A plaque near the lantern room in Sabine Pass's Bert Karrer/Lions Community Park describes the lighthouse's history. (Courtesy of Angie Kay Dilmore.)

The Fort Point lighthouse was discontinued in 1909 and repurposed as the Galveston Harbor Fog Signal Station. The last keeper at Fort Point was William B. Johnson, who worked there from 1903 to 1905. The wharf was built in 1900 to connect the boathouse to a railroad track that ran along the jetty. The track is no longer visible in the 1945 photograph below. Although the building was extensively damaged in the hurricane of 1915, it remained in use until 1950. The station building was removed in 1952, and the land was transferred to the US Army Corps of Engineers. Today, nothing remains at the site, which is close to the Bolivar Ferry Terminal and visible from the ferry as it leaves Galveston Island.

When it was built, the Brazos Santiago Life Boat Station was described as "the finest Coast Guard Station in the world, if rigid inspection and first quality of materials and workmanship count for anything." Both the old screwpile lighthouse and the lifesaving station are shown in this c. 1939 photograph.

In 1950, the wooden structure of the Brazos Santiago lighthouse caught fire and burned down, leaving only the screwpile platform. The light was then moved to the top of the lifeboat station, pictured here in 1955. The remains of the lighthouse are visible at lower right.

In the 1940s, it took a crew of four to maintain the Aransas Pass Lighthouse, as well as 40 other light beacons on the Corpus Christi, Rockport, and Aransas Pass channels. Pictured here are, from left to right, third assistant H.D. Merrick, second assistant E.A. Marshall, first assistant Clifton Roy L. Hinson, and head keeper William Browder. The Coast Guard required each light to be checked every four days, and it took nearly a week to complete the full circuit of 40 lights. The lights were frequently damaged by boating accidents or vandalism. The danger resulting from a damaged beacon could be serious, and Texas law was commensurately tough. Intentionally or mischievously removing any aid to navigation could result in two to five years in the penitentiary and a fine of up to $2,000. If a death occurred as a result of a missing beacon or buoy, the offender could be charged with murder. (Courtesy of the Aransas County Historical Commission Archives.)

In addition to maintaining the lighthouse and other navigational aids, keepers were responsible for the buildings in which they lived and worked. Married keepers lived at the stations with their wives and families. In the 1940s, Aransas Pass lighthouse head keeper William Browder and his wife, Isabel, had a six-year-old daughter, Marie, and first assistant Clifton Roy Hinson and his wife, Bertha, had a baby daughter named Patricia. The identity of this little fellow is unknown, but the station's residents did receive occasional visitors. Although the lighthouse was isolated, and some keepers must have suffered from boredom, the keepers and their families could travel by boat to Port Aransas when they were in need of company, and the Lighthouse Service circulated portable libraries. The lighthouse residents pursued hunting, fishing, oystering, and other hobbies as time allowed. (Courtesy of the Aransas County Historical Commission Archives; photograph by Roy Hinson.)

A keeper's hobbies might even include boatbuilding. First assistant lighthouse keeper Roy Hinson built this sailboat (pictured at left) while stationed at Aransas Pass in the early 1940s. According to local accounts, he built it on dry land under the small, elevated assistant keeper's cottage shown here. Once it was finished, Hinson dug a canal out to the adjacent bayou, waited for the tide to come in and fill the canal, and then floated the boat out into the bayou. The photograph below shows the location of the assistant keeper's cottage, closest to the water, and the remnants of the canal. Second assistant keeper Everett M. "Woody" Woodruff recalled that Hinson was quite a fisherman as well as a sailor. (Courtesy of the Aransas County Historical Commission Archives; photograph by Roy Hinson.)

An additional keeper's house (at left above) was built at Aransas Pass in 1938 or 1939. Prior to that, all four of the keepers lived together in the larger dwelling next to the tower. Once the new quarters were built, the head keeper moved into them, leaving the three assistants to share the remaining space. Although it was admittedly cramped, the crew and their families managed to get along and share common spaces such as the kitchen (pictured below). Keeper Everett M. Woodruff later recalled that the greatest challenge for the younger keepers was the isolation and lack of easy opportunities to socialize. (Above, courtesy of Corpus Christi Public Libraries, photograph by Jack Baughman; below, courtesy of the Aransas County Historical Commission Archives.)

The Aransas Pass station was discontinued in 1952 after the pass shifted to the south, and the light, then several miles away from the pass, was no longer useful as an aid to navigation. Since it was no longer located at the pass, the light was renamed for the Lydia Ann Channel. In 1955, the lighthouse's lamp was moved to the nearby lifeboat station (below), and the property was sold as surplus to Farnsworth & Chambers, a Houston-based construction company, and used as a fishing and hunting camp. The photograph above was taken in 1957. (Above, courtesy of Corpus Christi Public Libraries; photograph by Jack Baughman.)

In 1971, Charles E. Butt, owner of the Texas-based H.E.B. Grocery chain, purchased the Aransas Pass lighthouse property. Over the next 17 years, Butt invested in researching and restoring the dwellings and tower, complete with a 19th-century Fresnel lens that was previously displayed in a museum on the East Coast. Lighthouse keepers were hired, and they continue to maintain the property and turn on the beacon—which has been certified as a private aid to navigation—each evening. Part-time assistant keepers live on the mainland and are available to relieve the island-dwellers when necessary. Still isolated and only accessible by boat, the Aransas Pass/Lydia Ann Light remains private property and is open to visitors by invitation only. This 1960 photograph shows Jill Jeffers and Sally McCord with the lighthouse. (Courtesy of Corpus Christi Public Libraries; photograph by Jack Baughman.)

In 1991, members of the Aransas County Historical Society made a field trip to the Aransas Pass lighthouse. The keeper's cottage—built in 1919 to withstand hurricanes—is still sound, as shown in this rare view. The lighthouse is more commonly viewed from the water, where it is an attraction for boaters and paddlers. (Courtesy of the Aransas County Historical Commission Archives.)

In 2012, the tower's brick masonry was repaired. Old, damaged bricks were replaced with matching ones salvaged from an 1880 building in Alabama, and much of the tower was repointed with new mortar. The spiral staircase inside the tower has also been repaired; the center pole was replaced and the 72 steel steps were galvanized to prevent rust. (Courtesy of the Aransas County Historical Commission Archives.)

Keeper Arthur Barr and his wife, Ruth, were the last occupants of the Matagorda Island lighthouse. Arthur Barr joined the Coast Guard at age 19, and after completing active duty, he served as a volunteer surfman at the Port O'Connor Lifeboat Station before becoming an assistant lighthouse keeper at Matagorda in 1938. Three years later, he married Ruth Heinroth, the daughter of the head keeper. Ruth's family had a long history with the lighthouse; her grandfather, Theodore Olson, was the keeper from 1913 to 1917 and was buried on the property. These photographs were taken in 1940 (above) and 1950 (below). In 1945, Arthur became head keeper. In 1956, after the lighthouse was electrified and automated, the Barrs moved to Port O'Connor, but Arthur continued to maintain this and other lights until he retired in the 1960s.

The Fresnel lens was removed from the Matagorda Island lighthouse in 1977 and replaced by a smaller lamp, and the station remained in use until the mid-1990s. It was dark for only a few years before a Houston businessman, Dewey Stringer, and then–county judge Arlene Marshall organized the Matagorda Island Foundation to pursue a restoration project for the lighthouse property in partnership with the Texas Parks and Wildlife Department. The lighthouse was equipped with a solar-powered beacon and relit on December 31, 1999. The attendees of the relighting ceremony included Ruth Barr and her daughter, as well as the descendants of the first lighthouse keeper, James Cummings. In 2003, the lantern room was removed with a crane for repair and repainting. A concrete ring around the base of the lighthouse was repaired, and the tower was repainted, completing a $1.23-million restoration project. (Courtesy of the Matagorda Island Foundation.)

Maintenance is ongoing at the Matagorda Island lighthouse. Because the lighthouse is made of iron plates, it must be painted every few years to prevent the metal from rusting. Additional plans include reconstructing the keeper's house and other buildings (pictured here in May 1950), which no longer exist on the lighthouse property, and providing a way for visitors to reach the site. Matagorda Island is currently only accessible by private boat.

The Halfmoon Reef lighthouse was abandoned in 1942 after being damaged by a hurricane. It was slated for demolition, but the owners of the Bauer-Smith Dredging Service removed the wooden building in 1943 and hauled it to their dredging yard. In 1979, W.H. Bauer donated the building to Calhoun County; now restored, it serves as the visitor information center for Port Lavaca. (Courtesy of the Calhoun County Museum.)

Several of Texas's lighthouses or former lighthouse sites have been marked with monuments or plaques in order to recognize their significance. The marker for the Port Isabel lighthouse was placed in 1936 as part of the Texas centennial celebration. In 1935, more than $3 million was allocated to commemorate the state's 100th anniversary of independence from Mexico. Across the state, more than 1,100 markers, memorials, or buildings were erected to commemorate historic events and early patriots of Texas. This granite marker for the "Old Point Isabel Lighthouse" calls it "the beacon for the commerce of the Rio Grande." It is the only lighthouse in Texas with a centennial monument and also the only lighthouse regularly open for public tours (available through the Museums of Port Isabel and the Texas Department of Parks and Wildlife). (Courtesy of Corpus Christi Public Libraries.)

The Port Isabel centennial marker was unveiled and dedicated during a ceremony (pictured above) in 1936. Bishop Mariano Simon Garriga, the first bishop of a Texas Catholic diocese to be born in the state, attended the ceremony. Garriga's schooling, religious assignments, and military service took him around the world. In 1936, he returned to Corpus Christi as the third bishop of the diocese there. Garriga's father, Frank, served as the lighthouse keeper in 1895, when Mariano Simon was nine years old. The photograph of Bishop Garriga at right was probably taken in 1961, when he celebrated his Jubilee year; he died in 1965. (Both, courtesy of Corpus Christi Public Libraries.)

The Texas Historical Commission works with members of county historical commissions, historical societies, and other individuals to erect markers like this one at the Aransas Pass Light Station. In addition to markers for the Texas Centennial, the state erected monuments during the 100th anniversary of the Civil War, including the Dick Dowling statue and memorial at the Sabine Pass Battleground Historical Site (pictured on page 75). The current marker program, which began in 1962, uses plaques like this to commemorate the history and architecture of houses, commercial and public buildings, religious congregations, and military sites; events that changed the course of local and state history; and individuals, community organizations, and businesses that have made lasting contributions to the state. The Aransas Pass marker was dedicated in 1973, shortly after the lighthouse was restored by Charles Butt. (Courtesy of the Aransas County Historical Commission Archives.)

This photograph, taken at the dedication of the Corpus Christi lighthouse marker erected at the site of the former lighthouse in 1973, shows county judge Robert Barnes and Phyllis Burson, director of the Corpus Christi Public Libraries, helping to place the historical marker near the corner of Buffalo and North Upper Broadway Streets. The marker is located across from the historic Southern Minerals Company (SOMICO) building, located at 807 North Upper Broadway, most recently known as a former headquarters of the H-E-B grocery chain. Other lighthouses (or sites of former lighthouses) that are recognized with markers include Bolivar Point (dedicated in 1993) and Halfmoon Reef (1980) in Port Lavaca, as well as the site of the Halfmoon Shoal lighthouse in Texas City (1991). A replica of the Halfmoon Shoal lighthouse is located next to that marker on Bay Street Park in Texas City. (Courtesy of Corpus Christi Public Libraries.)

ROUTE MAP for VISITING TEXAS LIGHTHOUSES and RELATED MUSEUMS

Today, curious lighthouse fans can take a driving tour of Texas lighthouses and associated museums in the course of a week. A suggested agenda might look something like this: (day one) Sabine Pass, Port Arthur, and Bolivar Peninsula—visit Bert Karrer/Lions Community Park in Sabine Pass and the Museum of the Gulf Coast in Port Arthur, drive past the (privately owned) Bolivar lighthouse, take the Bolivar ferry past Fort Point, visit the Galveston College campus; (day two) Galveston Bay—explore the Texas City Museum and the Halfmoon Shoal lighthouse replica at Bay Street Park, take a Port of Houston boat tour past the former site of the Clopper's Bar lighthouse; (day three) Angleton, Surfside, and Freeport—visit the Brazoria County Historical Museum, Freeport Historical Museum, and Surfside Beach (formerly Velasco); (day four) Matagorda Bay—explore Matagorda Island and the Calhoun County Museum, visit the Halfmoon Reef lighthouse visitors center in Port Lavaca; (day five) Aransas Bay—kayak or boat past the Lydia Ann Channel light, visit the Port Aransas Museum; (day six) Corpus Christi—visit the Museum of Science and History; (day seven) Port Isabel—visit the Museums of Port Isabel. (Map created by the author.)

BIBLIOGRAPHY

Anderson, John B. and Antonio B. Rodriguez. "Subsidence of the Changing Shoreline—The Episodic Evolution of Galveston Bay: Implications for Future Response to Global Change." *Proceedings, State of the Bay Symposium V, Publication GBNEP-T5, January 31-February 2, 2001,* by the Galveston Bay Estuary Program, 123–136. Webster, Texas: Galveston Bay Estuary Program.

Baker, T. Lindsay. *Lighthouses of Texas.* College Station, TX: Texas A&M University Press, 1991.

Cipra, David L. *Lighthouses, Lightships, and the Gulf of Mexico.* Alexandria, VA: Cypress Communications, 1997.

Clifford, Mary Louise and J. Candace Clifford. "Navigational aids Provided by the Lighthouse Bureau – Part I: Early development of aviation and the formation of the Airways Division in the Lighthouse Bureau." *The Keeper's Log,* US Lighthouse Society (Summer 2008).

Cotham, Edward T. *Sabine Pass: The Confederacy's Thermopylae.* Austin, TX: University of Texas Press, 2000.

Marshall, Amy K. "Frequently Close to the Point of Peril: A History of Buoys and Tenders in U.S. Coastal Waters 1789–1939." Master's thesis, East Carolina University, 1997.

National Register of Historic Places. "U.S. Government Life-saving Stations, Houses of Refuge, and pre-1950 US Coast Guard Lifeboat Stations." Multiple Property Listing, United States, 64501177.

Discover Thousands of Local History Books
Featuring Millions of Vintage Images

Arcadia Publishing, the leading local history publisher in the United States, is committed to making history accessible and meaningful through publishing books that celebrate and preserve the heritage of America's people and places.

Find more books like this at
www.arcadiapublishing.com

Search for your hometown history, your old stomping grounds, and even your favorite sports team.

Consistent with our mission to preserve history on a local level, this book was printed in South Carolina on American-made paper and manufactured entirely in the United States. Products carrying the accredited Forest Stewardship Council (FSC) label are printed on 100 percent FSC-certified paper.

MADE IN THE USA